Empowering Skulls :
A Journey of Strength,
Mindfulness, and Positivity

Lex, Max & Belle

Let your passions fuel your journey

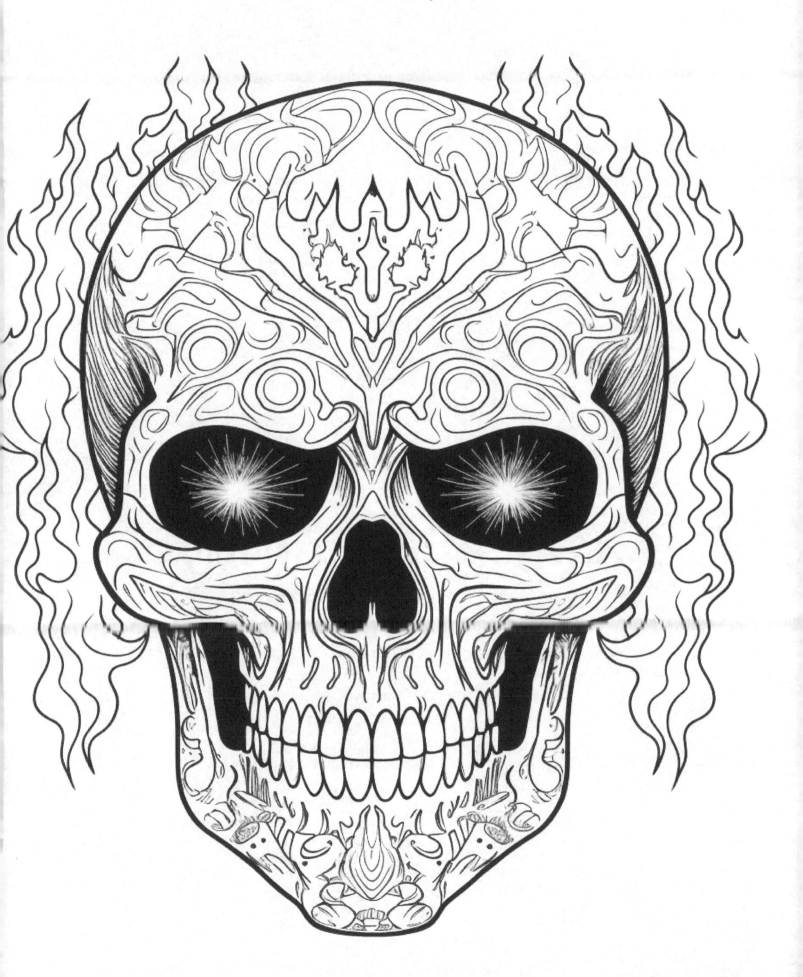

Let your creativity flow like a river

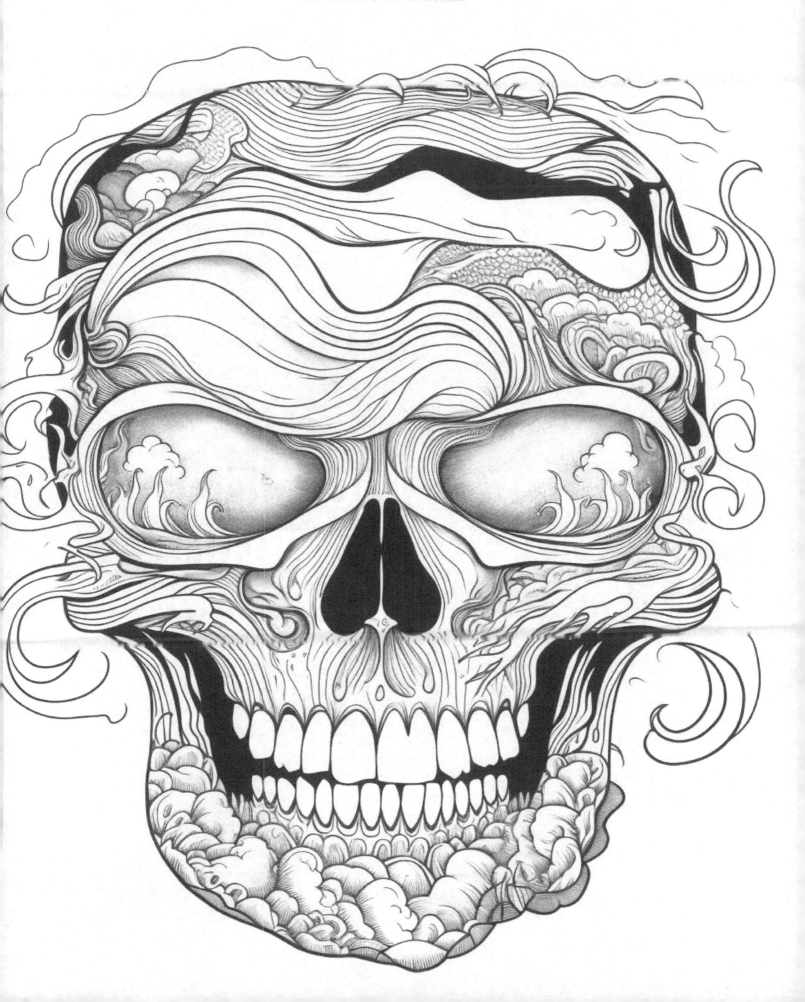

Uncover the hidden potential within you

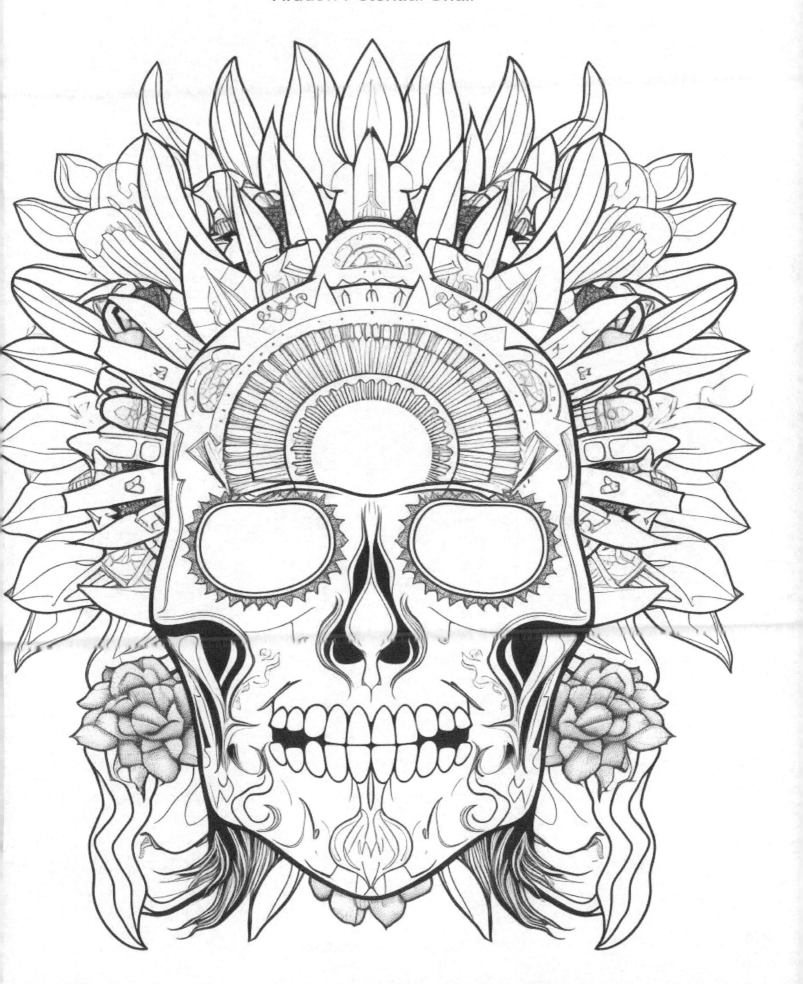

Dare to dream big and achieve greatness

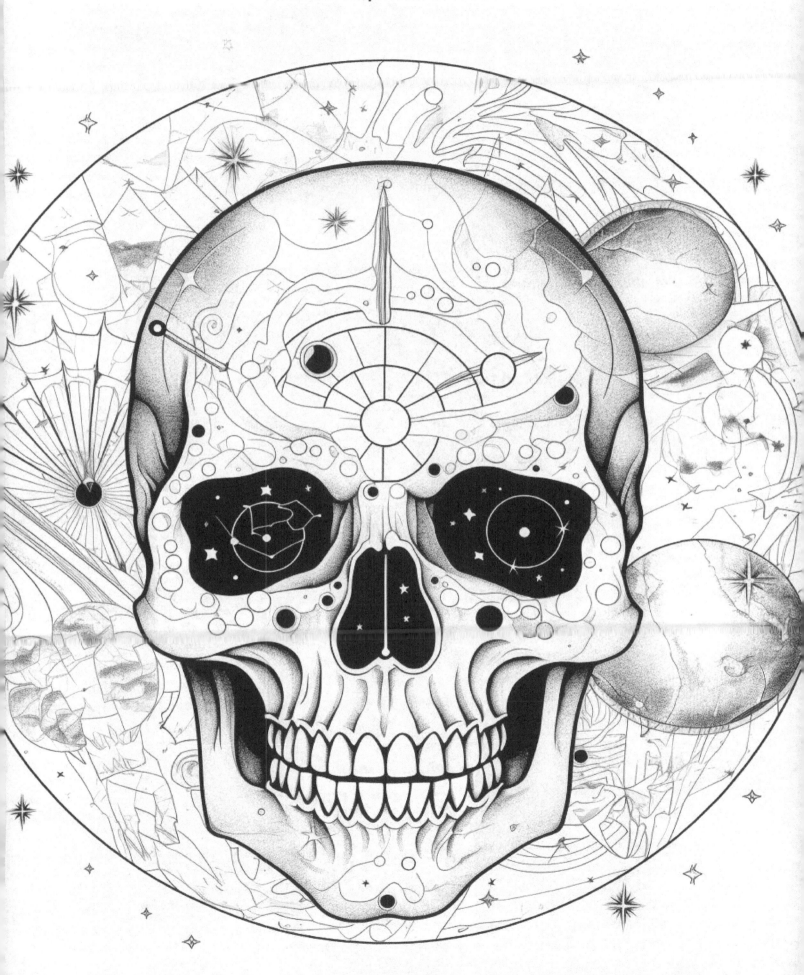

Embrace the rhythm
of life and dance
to your own beat

Rhythmic Dance Skull

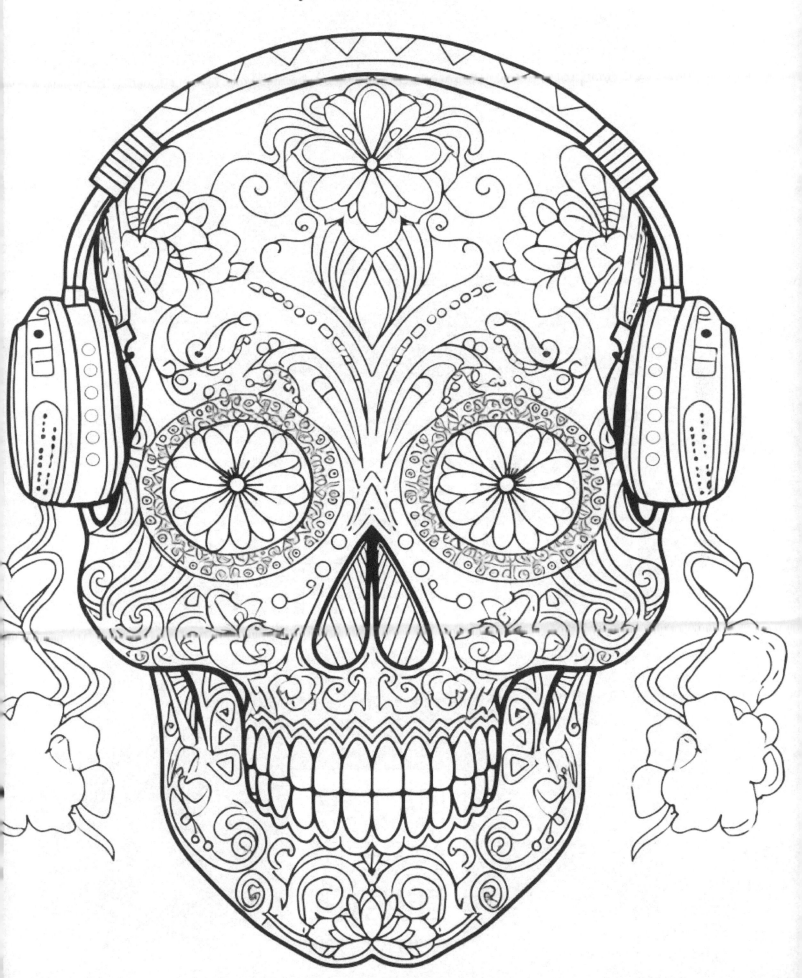

Believe in the power of your own strength

Inner Strength Skull

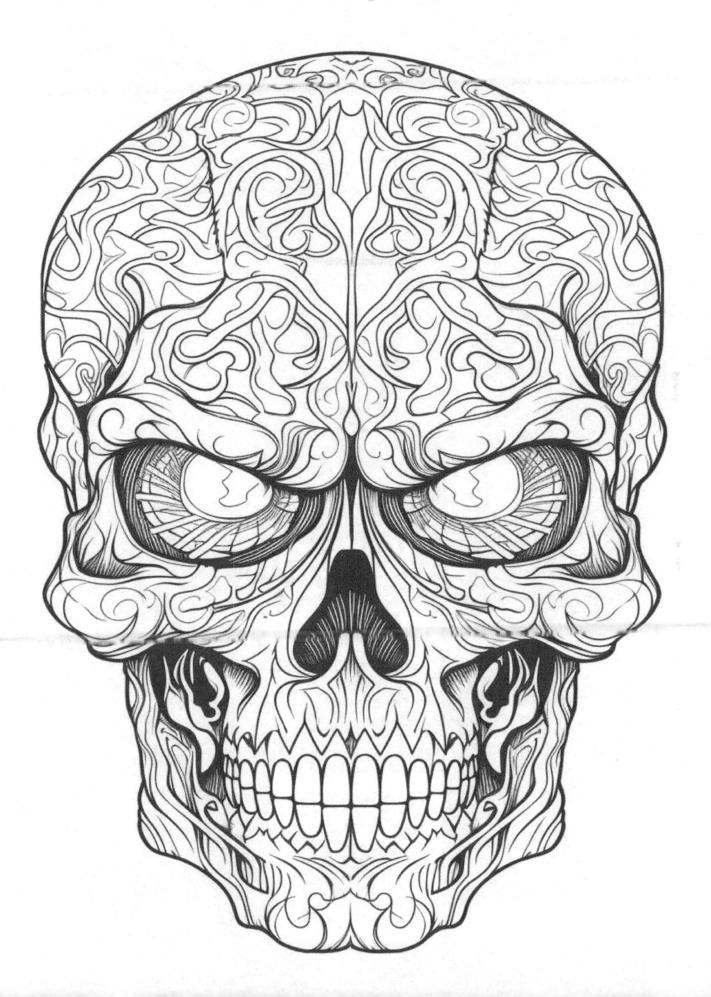

Love and accept
yourself
unconditionally

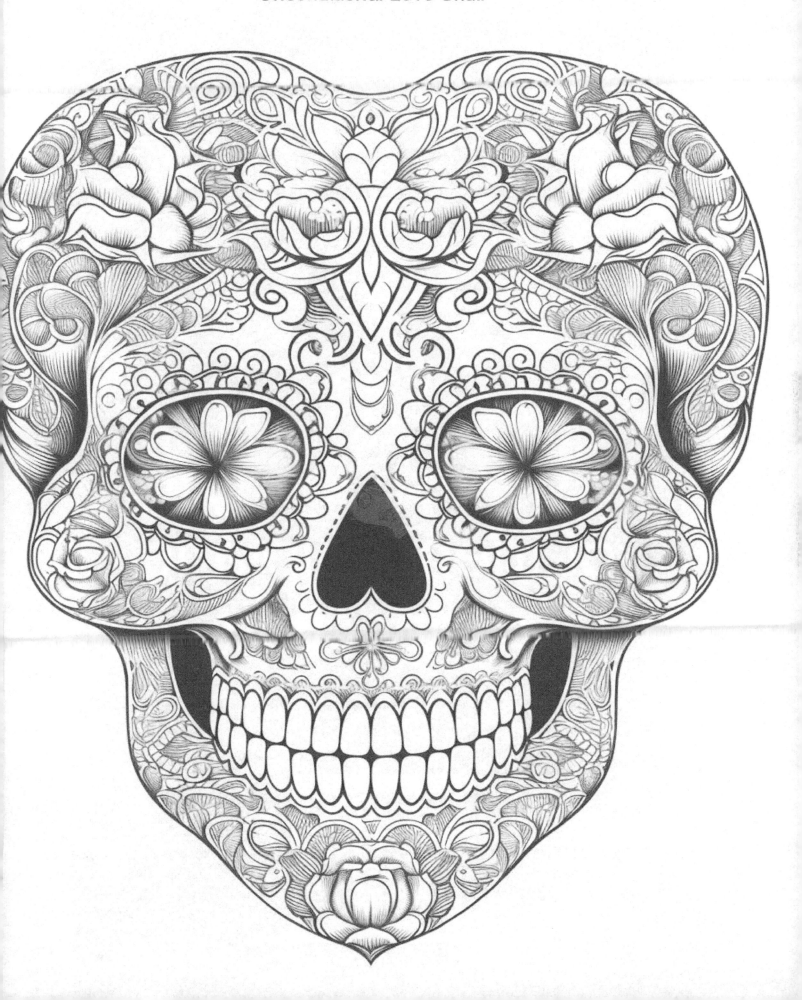

Cherish the gift of friendship and connection

Bonded Souls Skull

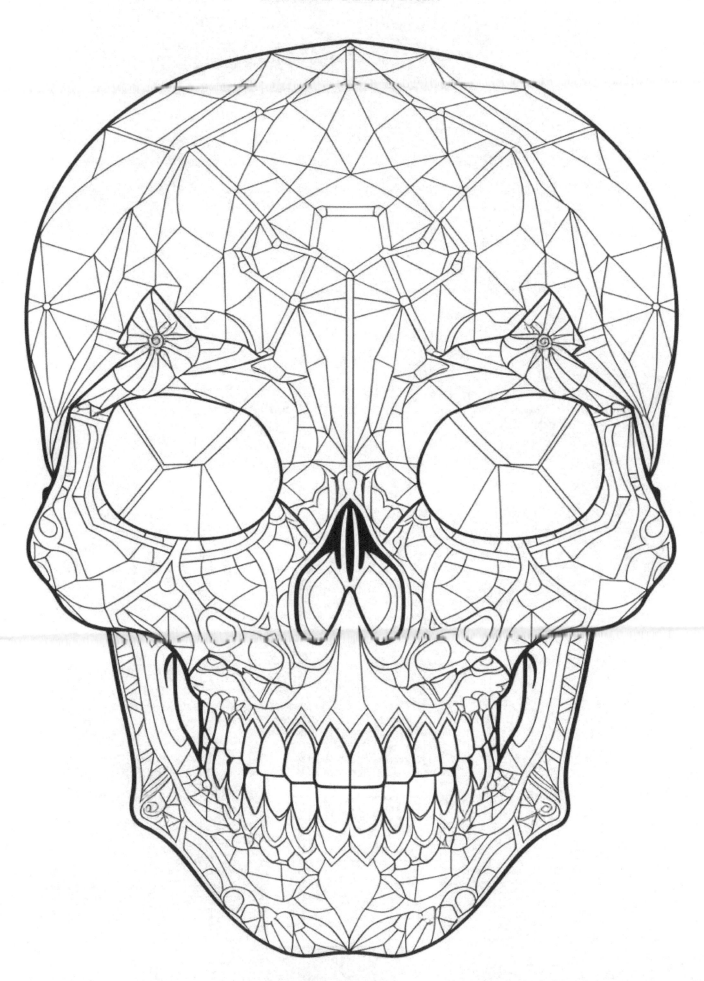

Transform your fears into courage

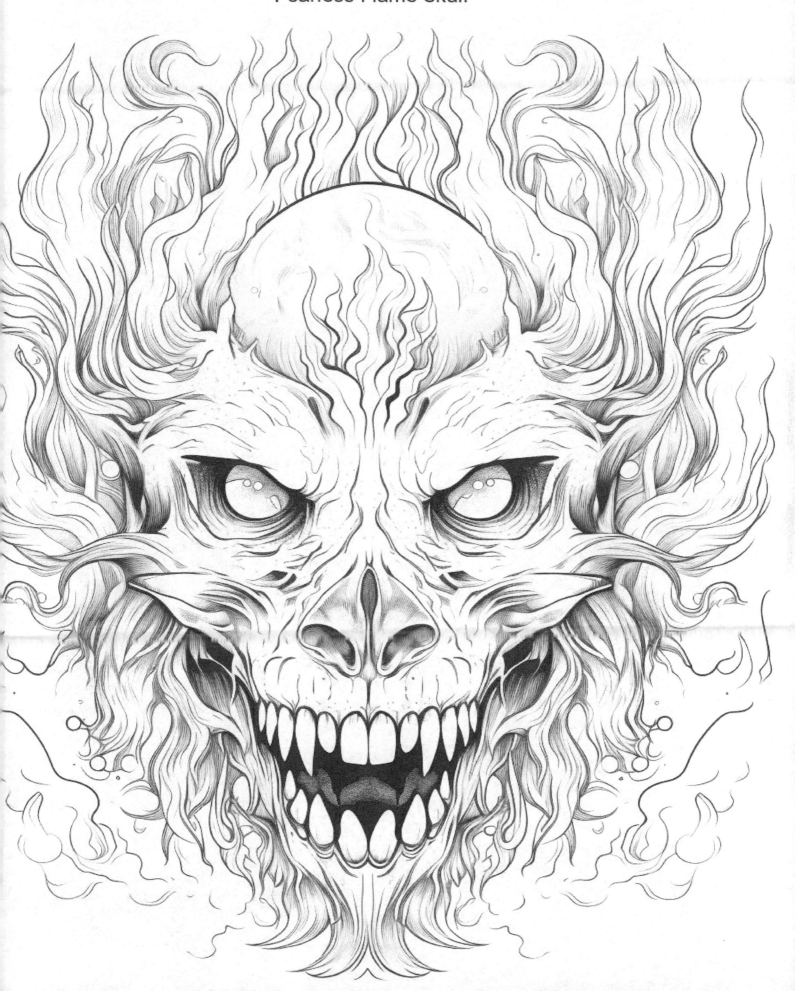

Every breath you take is an opportunity for gratitude

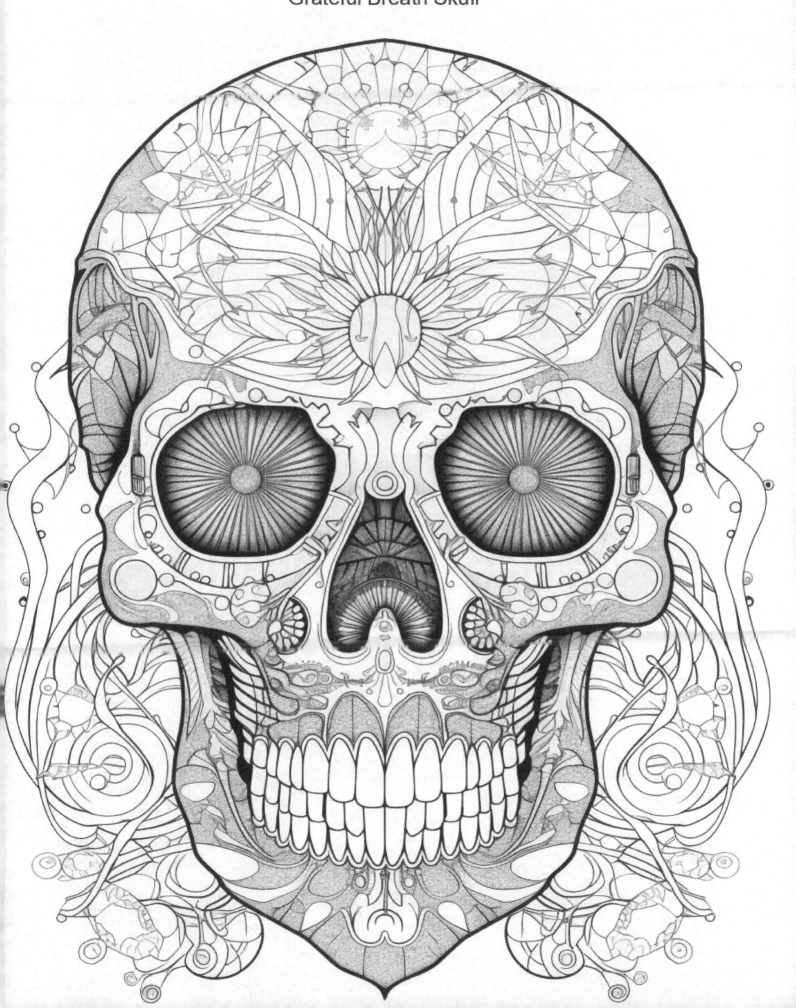

Grateful Breath Skull

Let your positive energy light up the world

Radiant Energy Skull

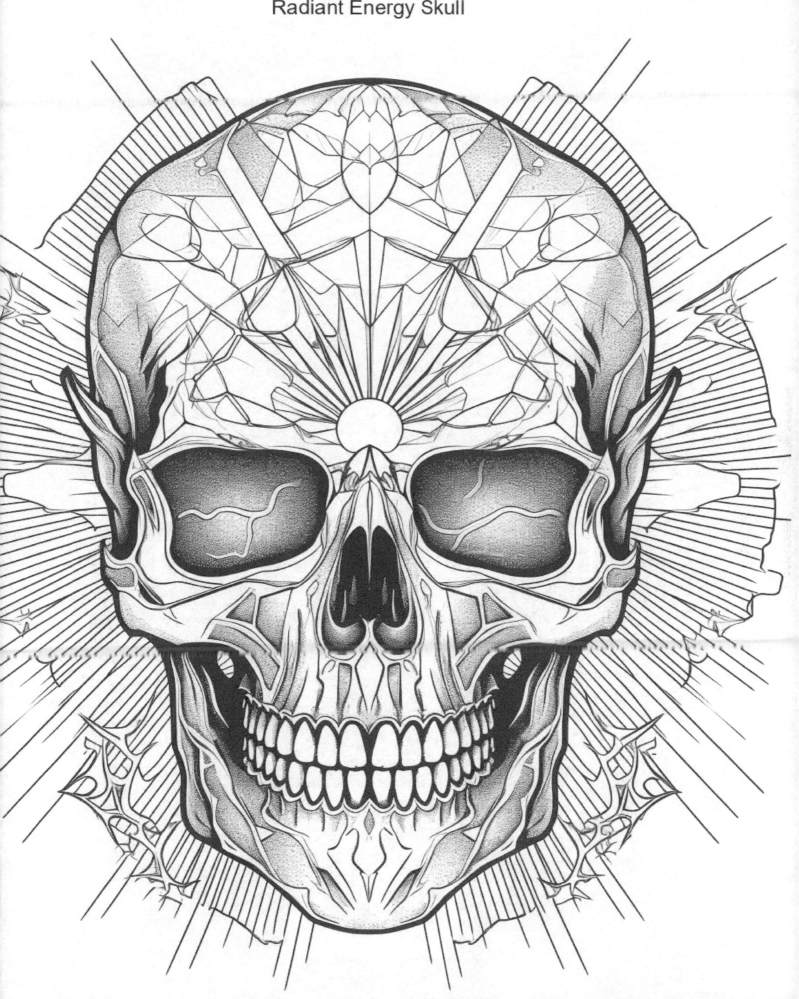

Embrace the wisdom that comes with age

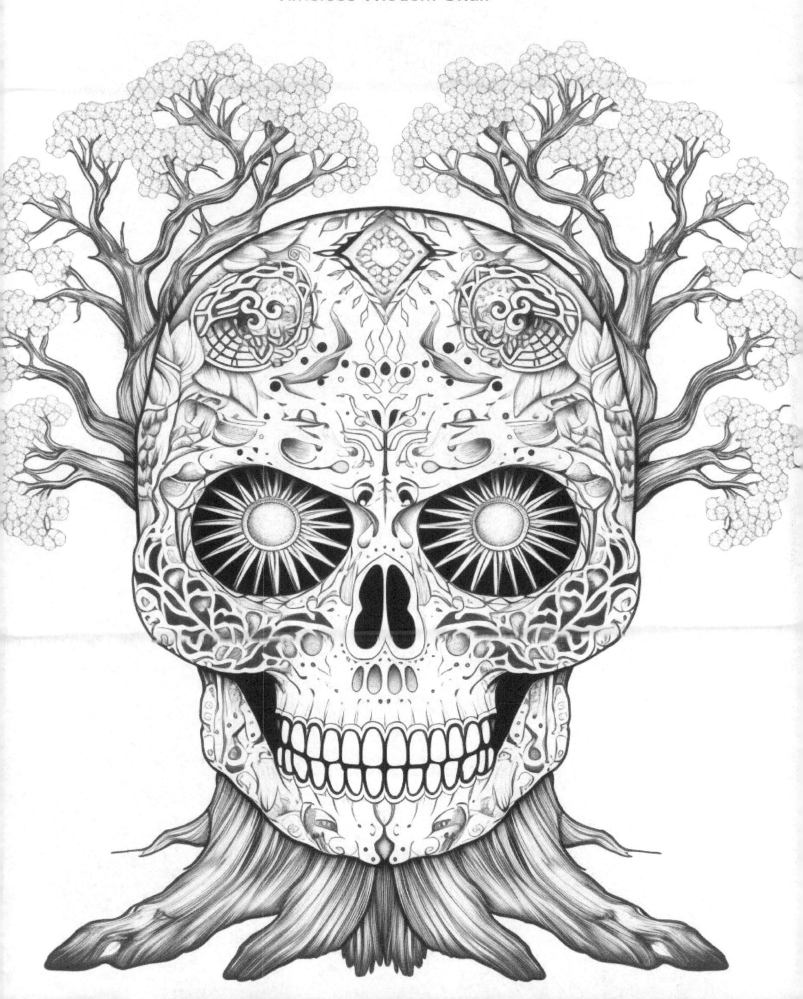

Choose to see the beauty in every challenge

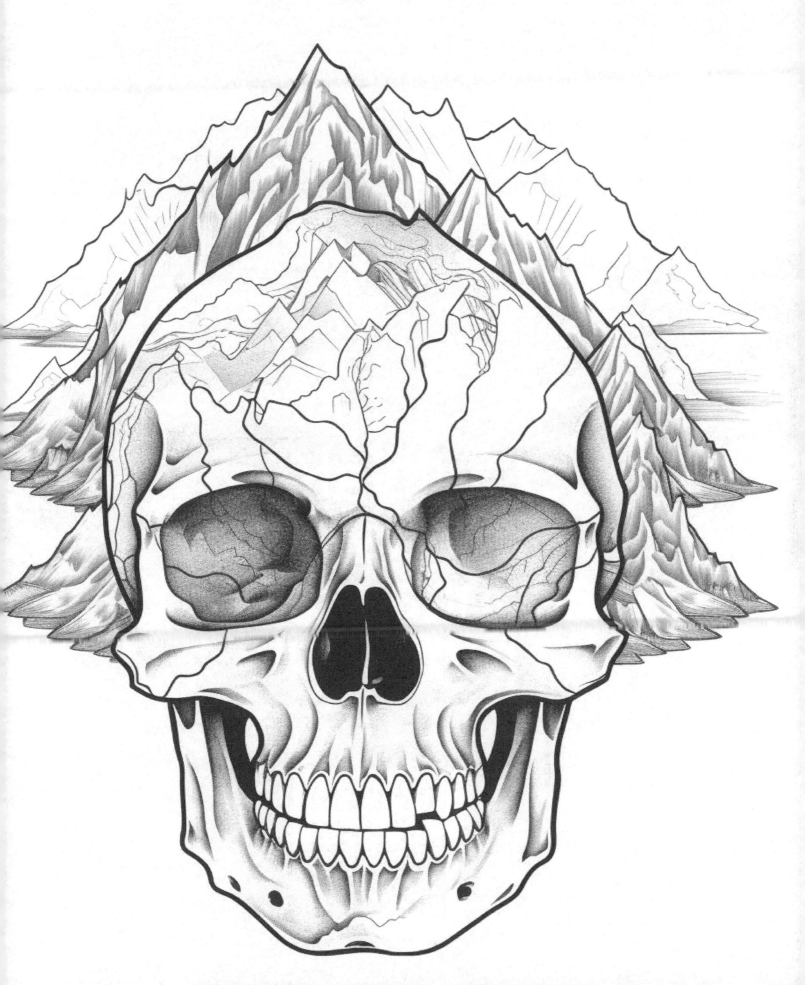

Cultivate a mindset of abundance and prosperity

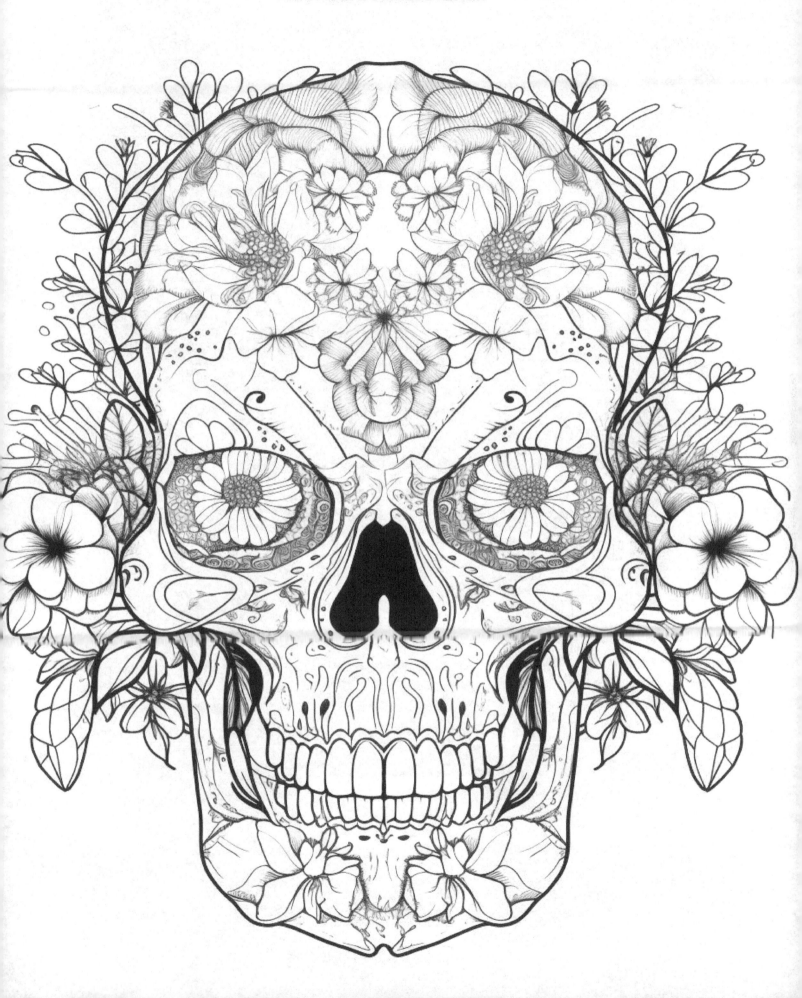

You are the author
of your own story

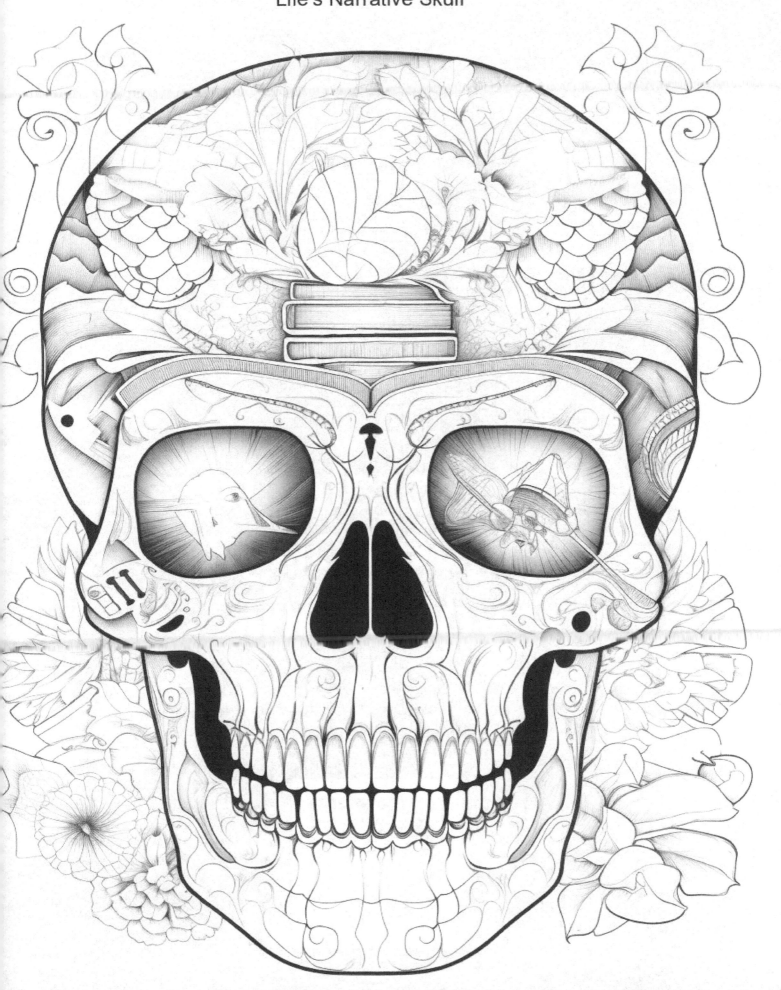

Celebrate the unique song of your soul

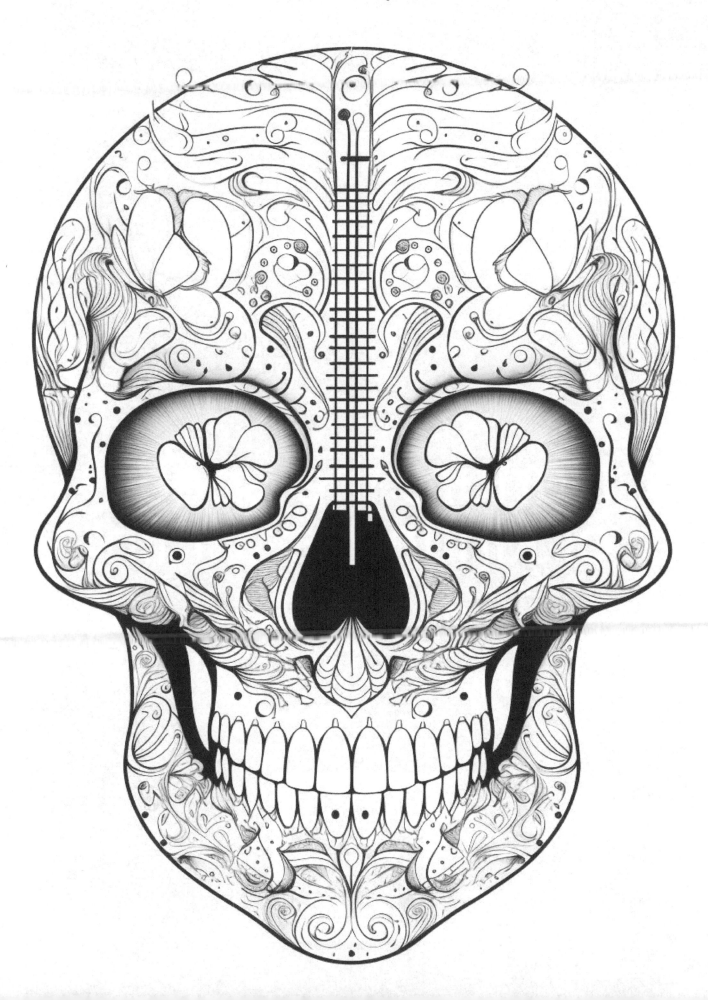

Soulful Melody Skull

Nurture the seeds of kindness within you

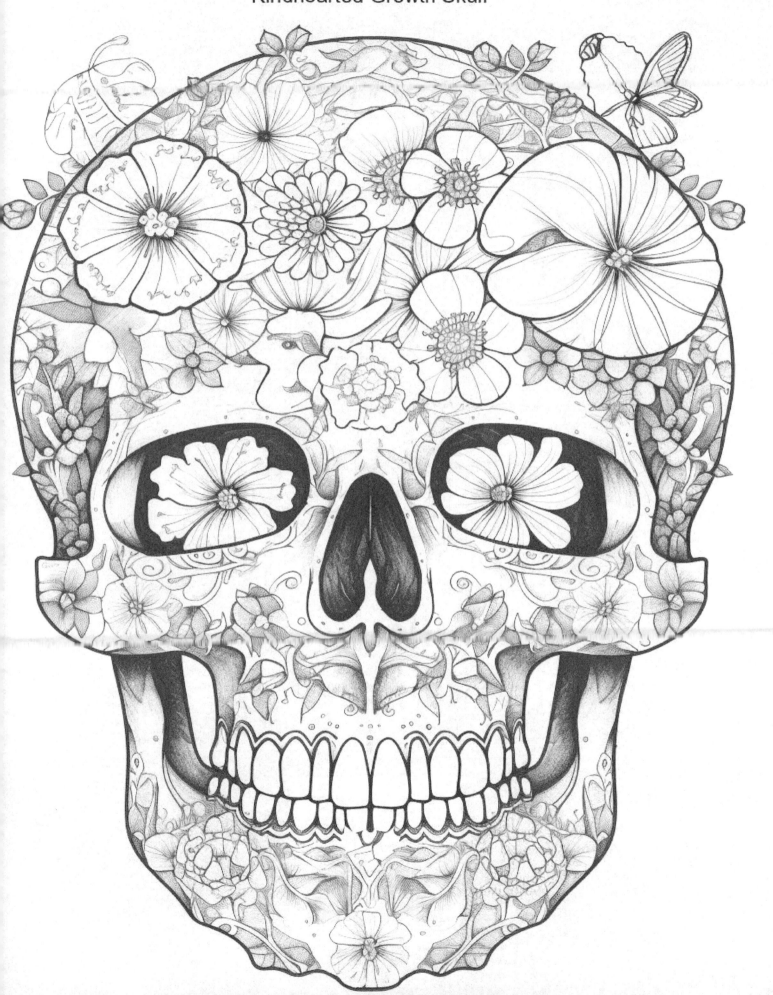

Recognize the power of resilience in times of adversity

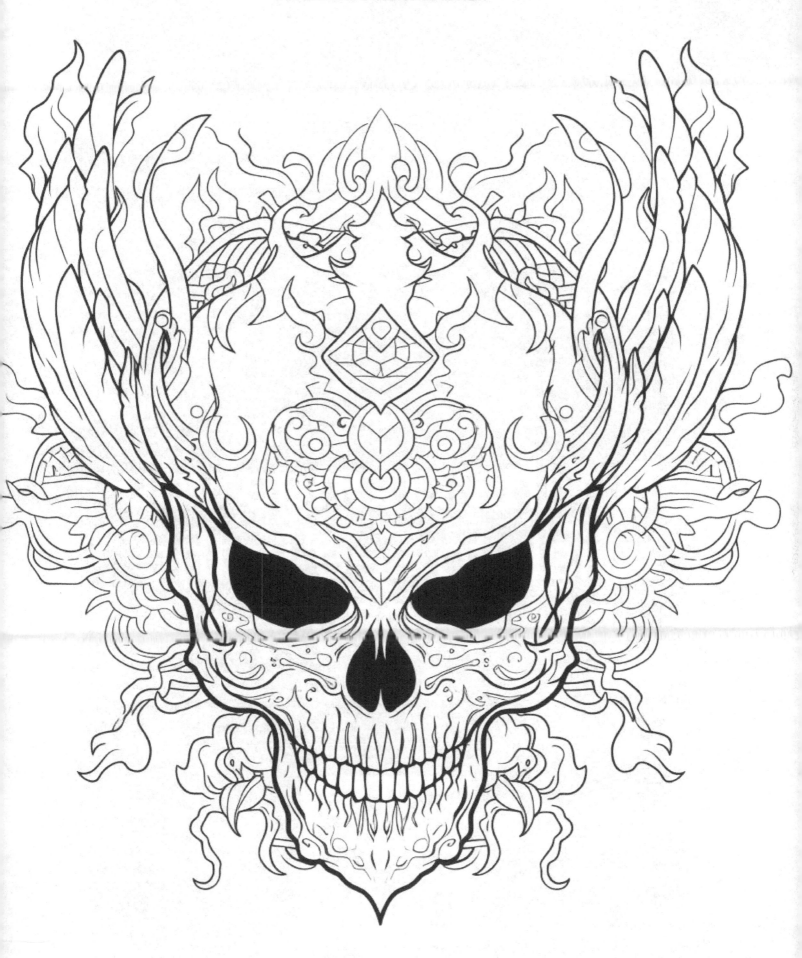

Resilient Phoenix Skull

Be the change you wish to see in the world

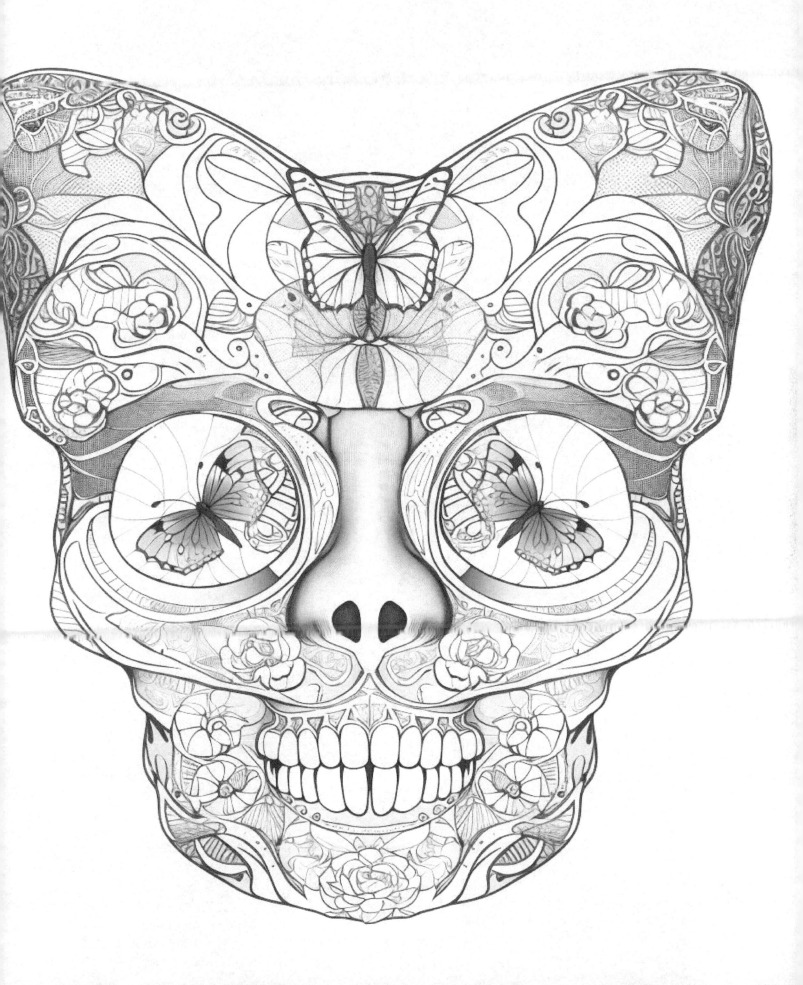

Metamorphic Change Skull

Embrace the support of your loved ones

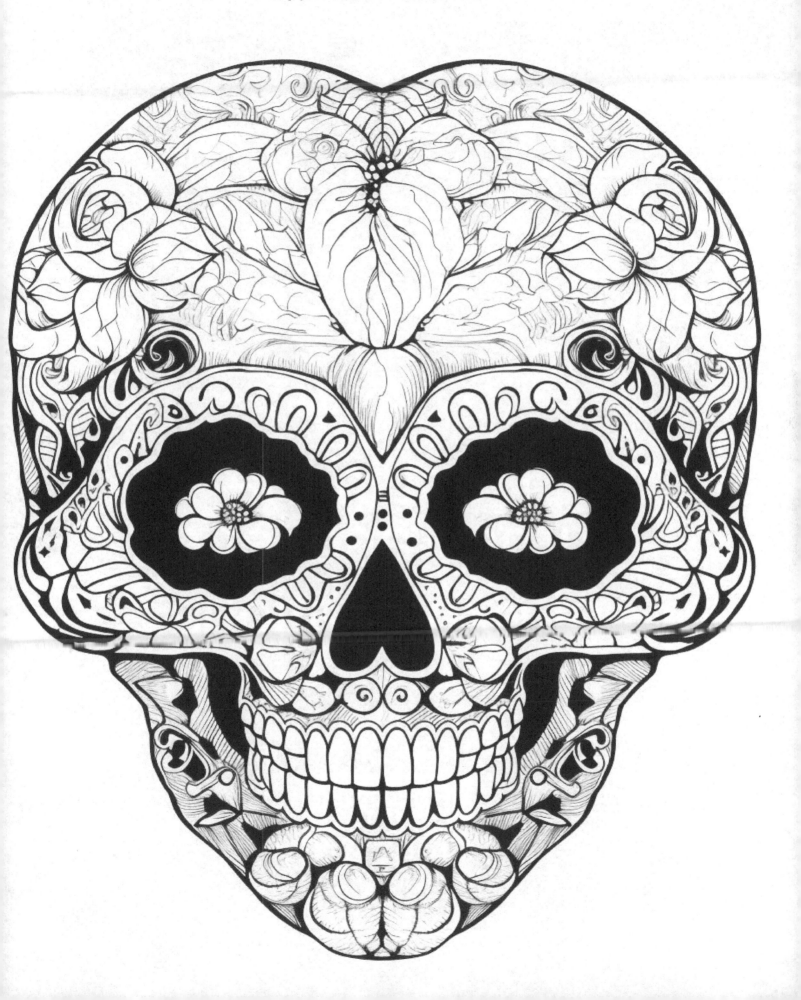

Trust in the journey and let go of expectations

Explore the depths of your own soul

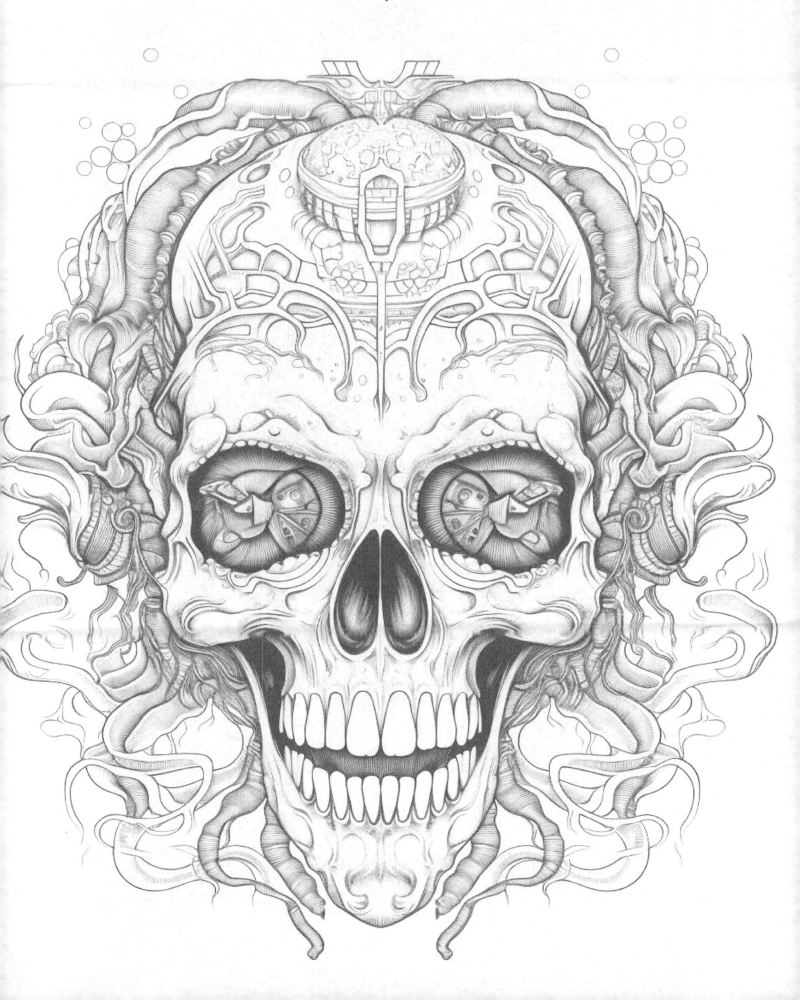

Find balance and harmony in all aspects of life

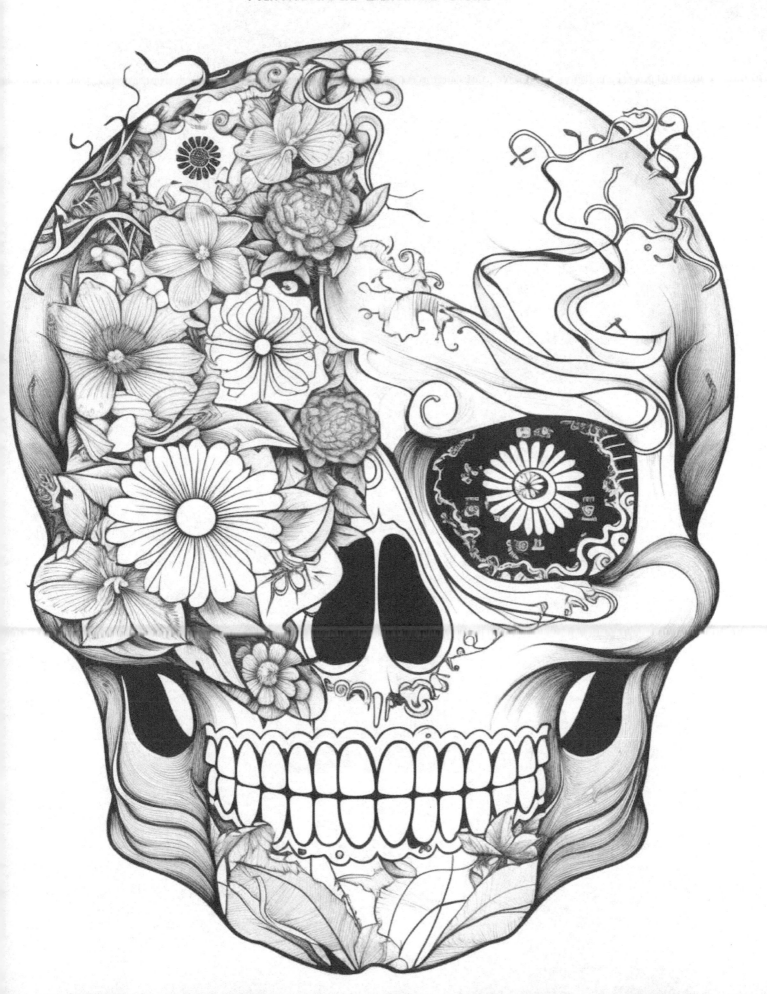

Keep moving forward, one step at a time

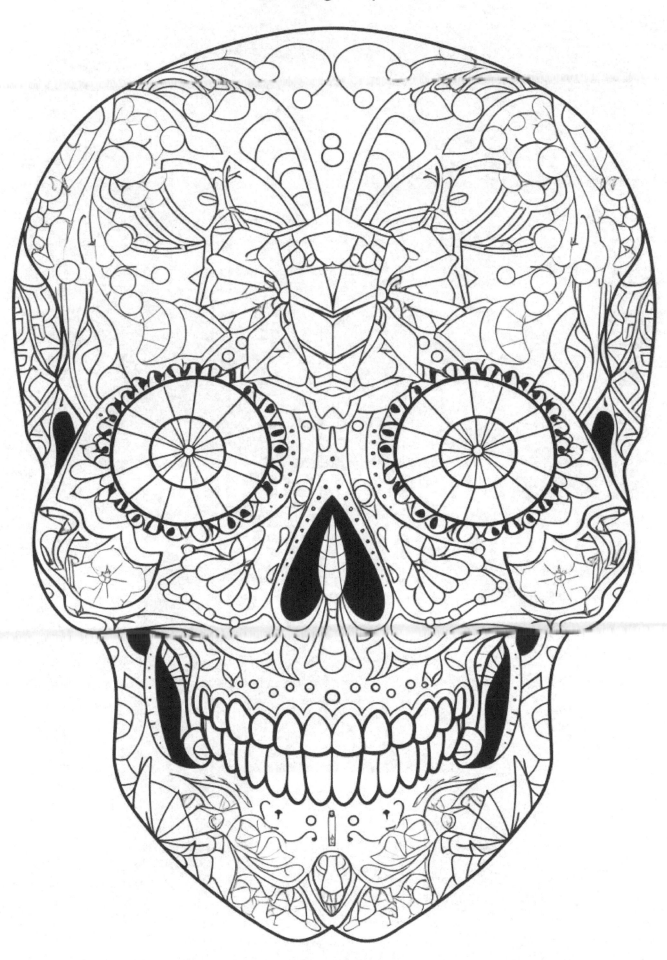

Discover the hidden treasures within you

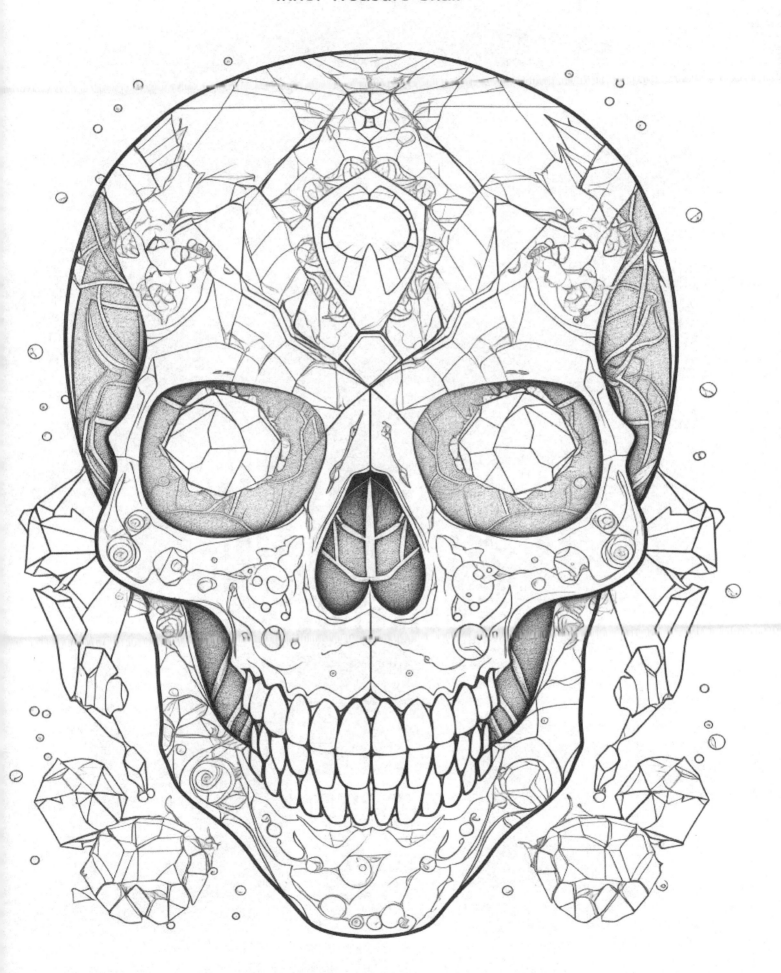

Awaken to the beauty of the world around you

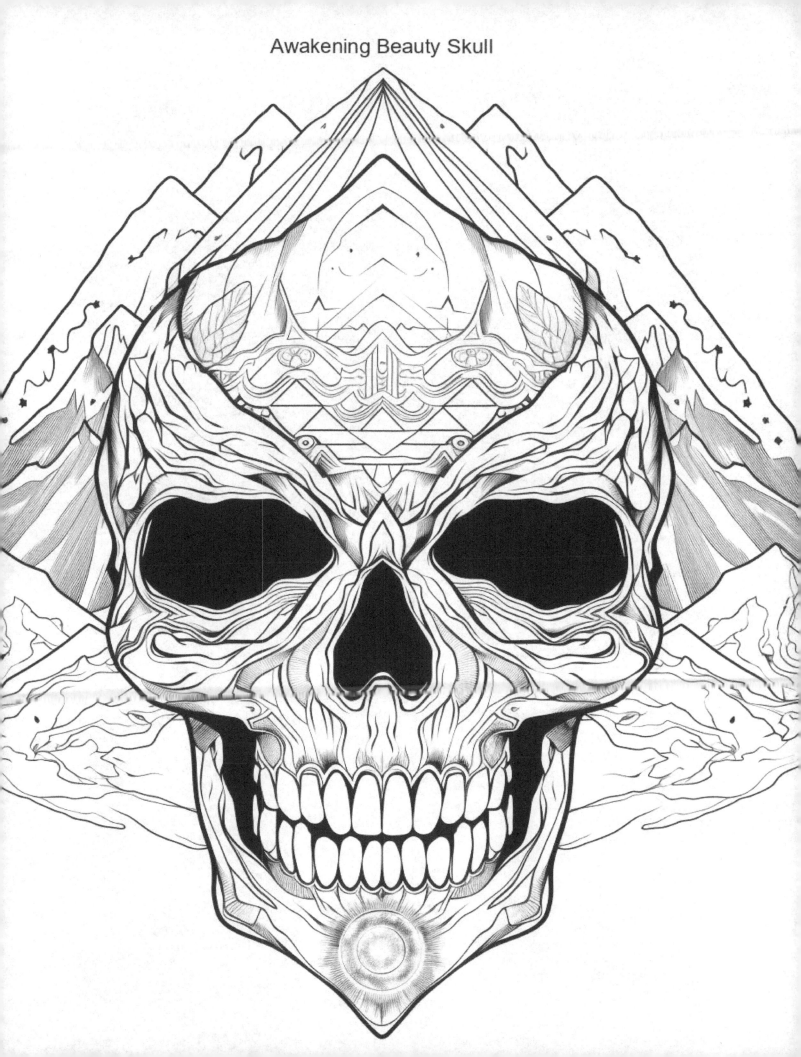

Take time to appreciate the small wonders of life

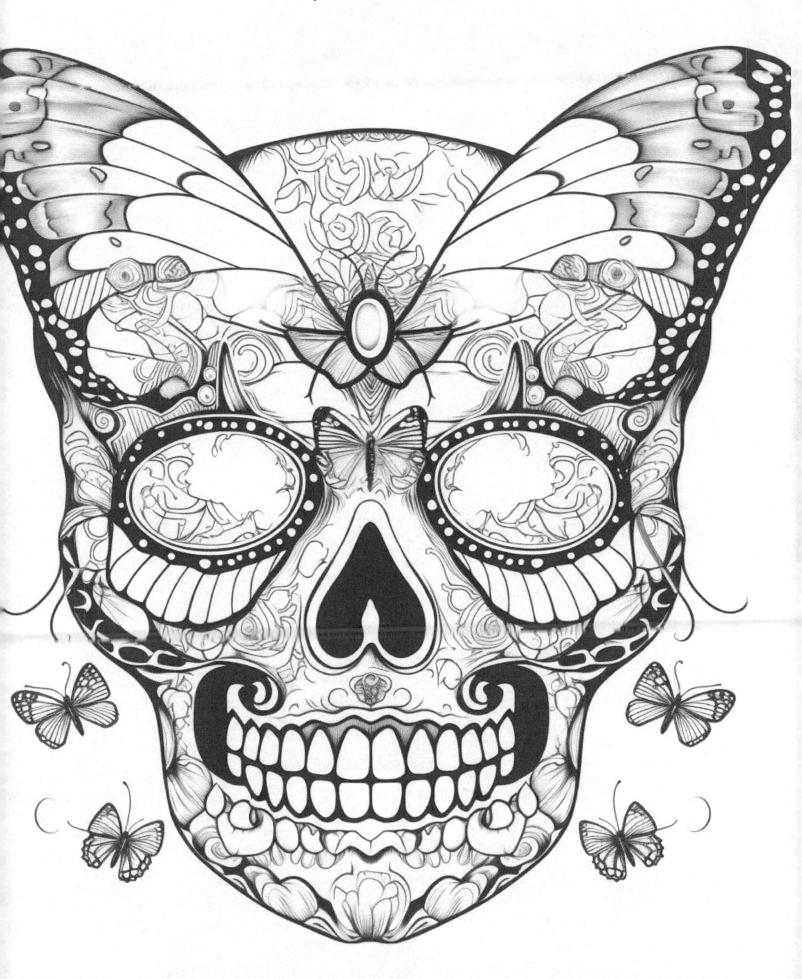

Cultivate a spirit of adventure and curiosity

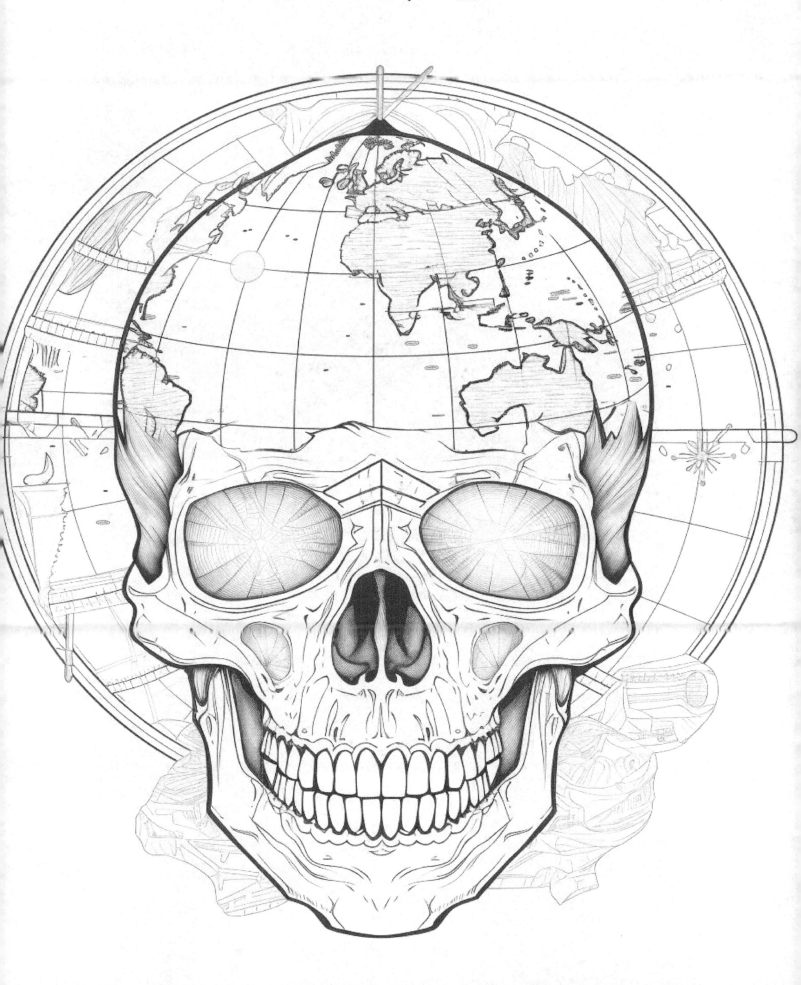

Laugh often and embrace the joy in life

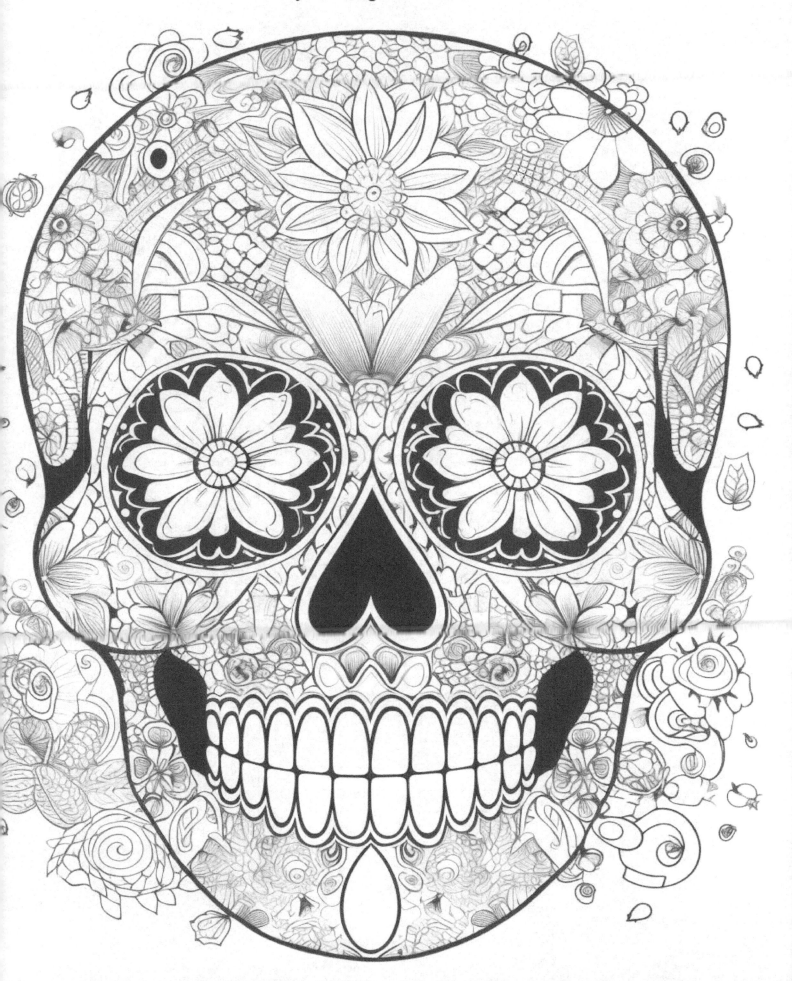

Joyful Laughter Skull

Dream without limits and manifest your desires

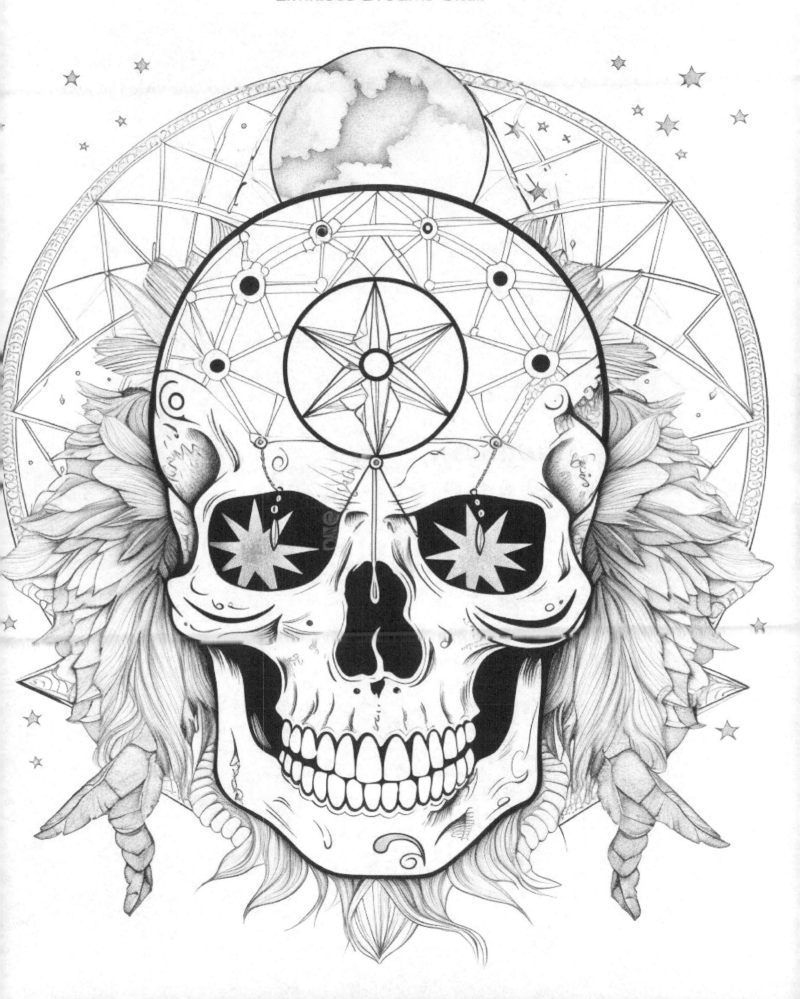

Embrace the healing power of nature

Healing Nature Skull

Cultivate inner peace and tranquility

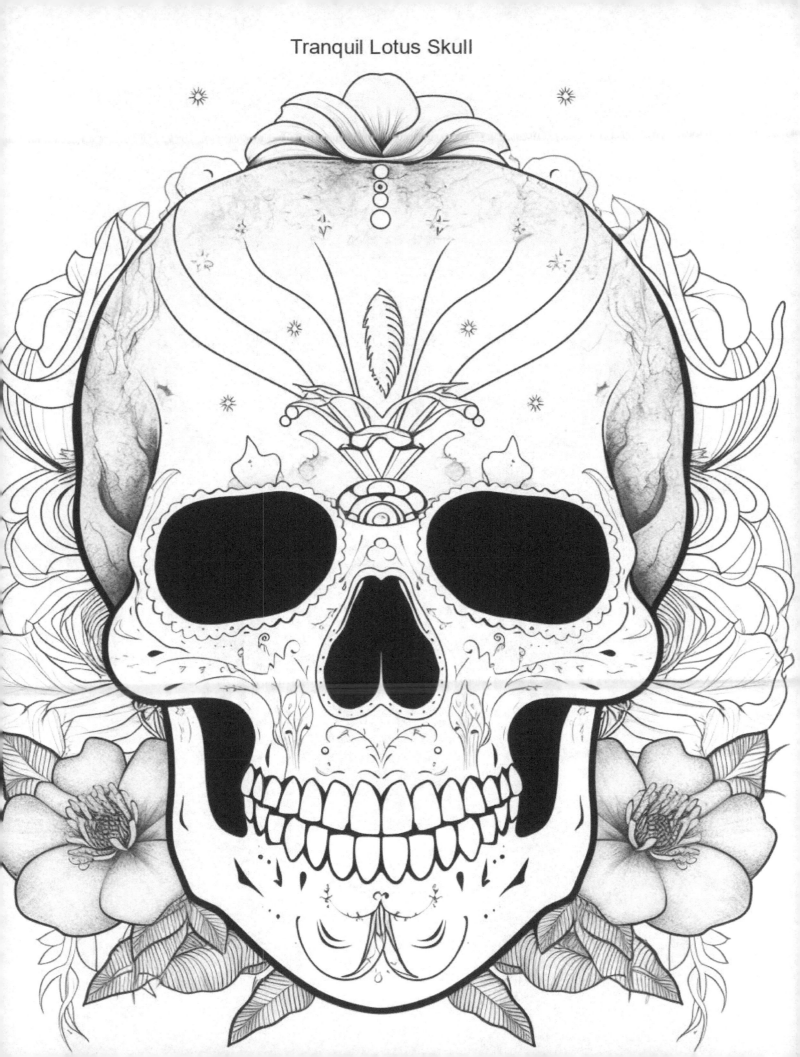

Embrace your uniqueness and let your light shine

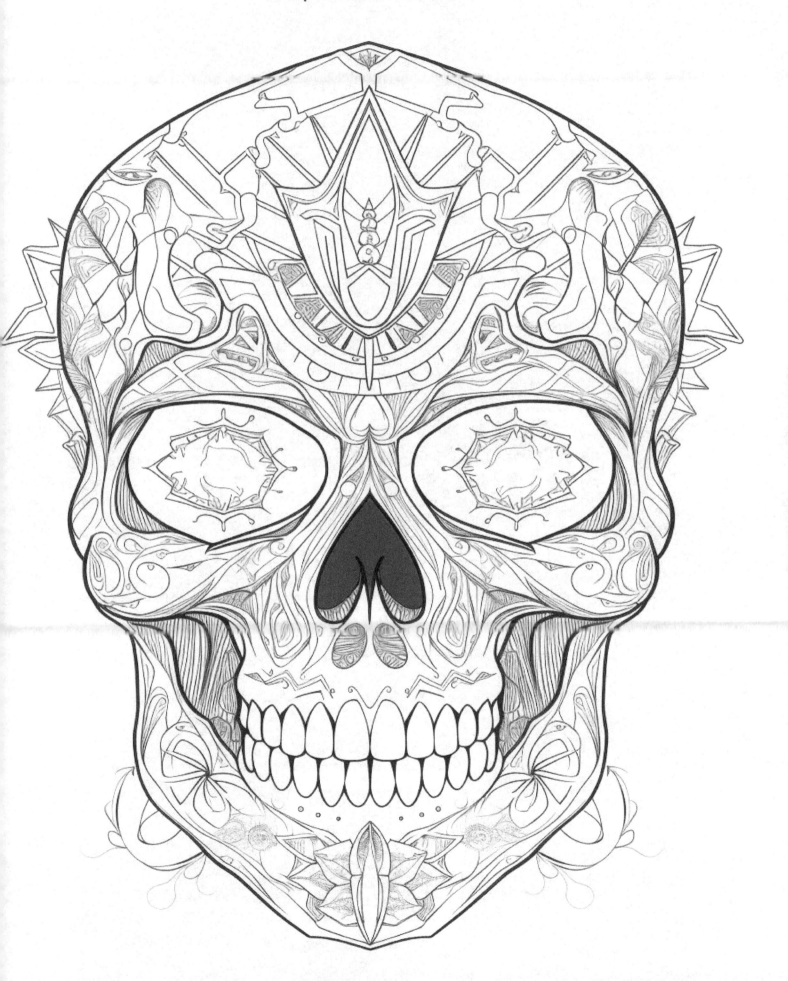

Honor your roots and celebrate your heritage

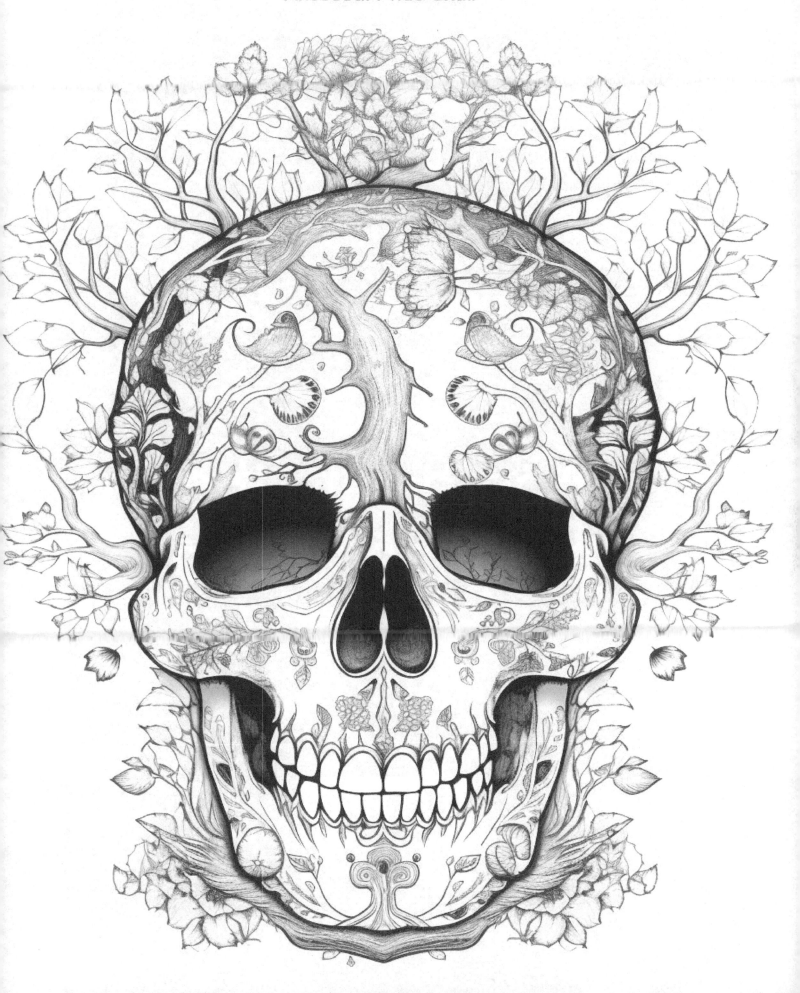

Appreciate the interconnectedness of all living things

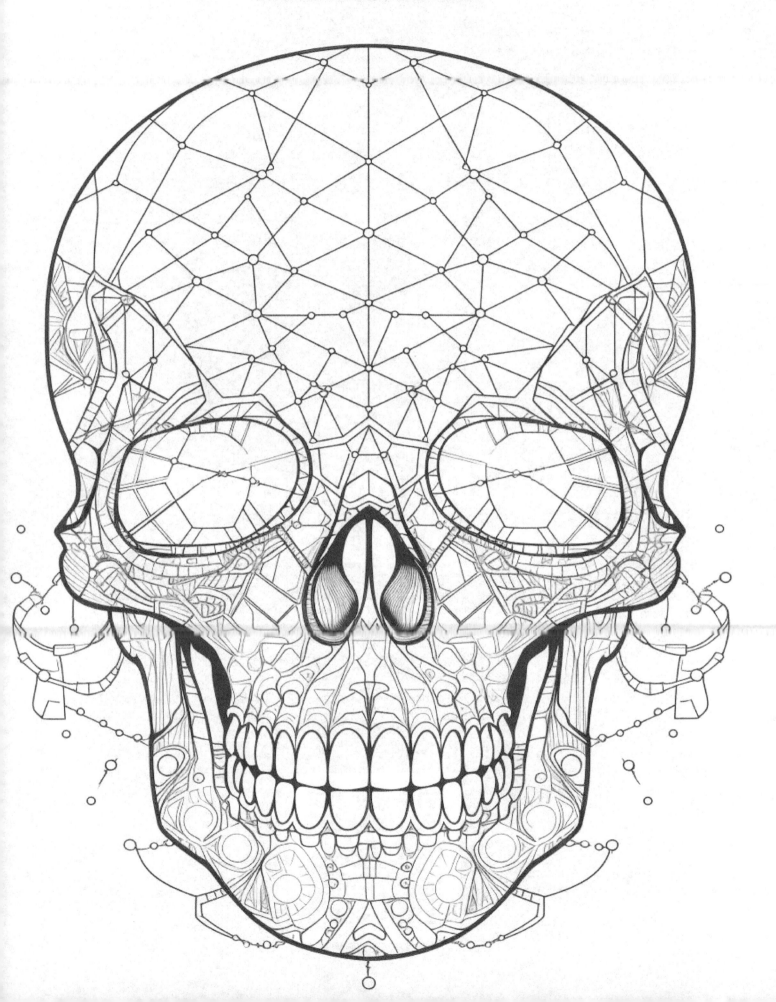

Let the winds of change guide your sails

Embrace your inner warrior and face your fears

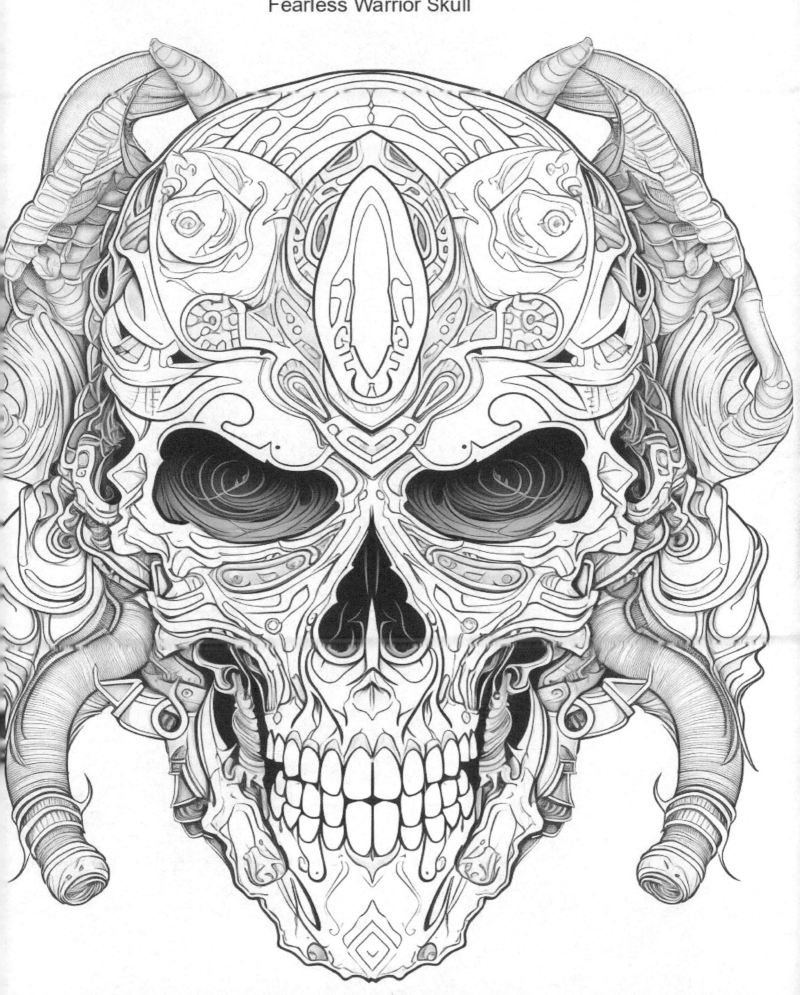

Fearless Warrior Skull

Nurture the creative spirit within you

Creative Blossom Skull

Embrace the transformative power of love

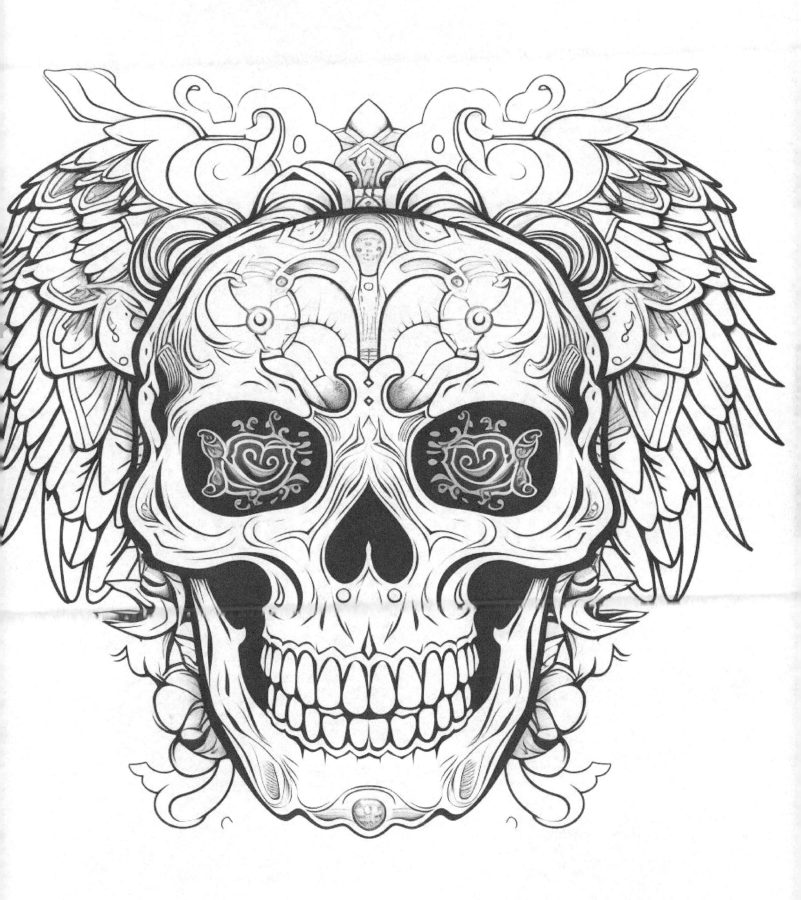

Honor the cycles of life and the passage of time

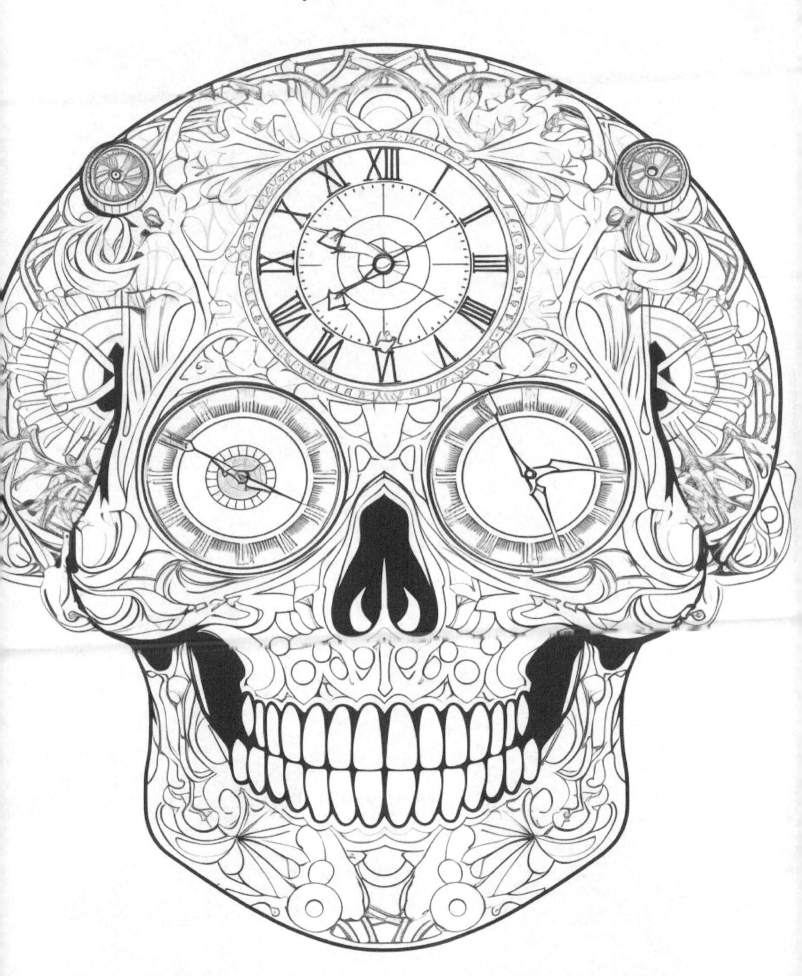

Cycles of Time Skull

Find the courage to break free from limitations

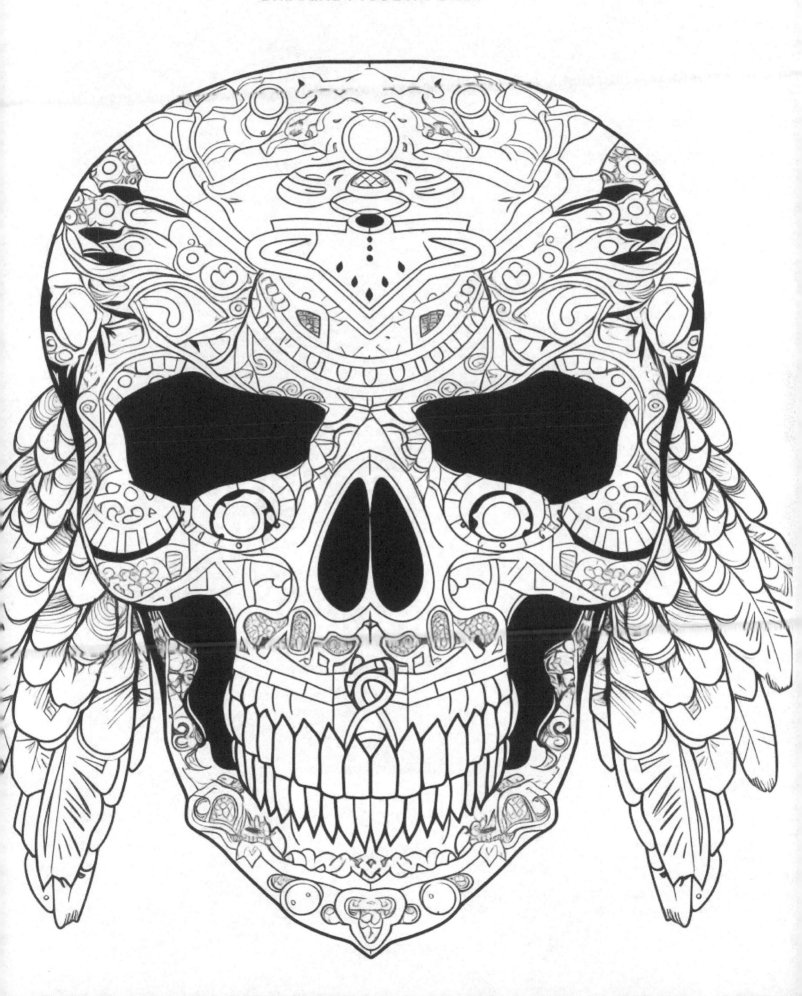

Seek inner wisdom through self-reflection

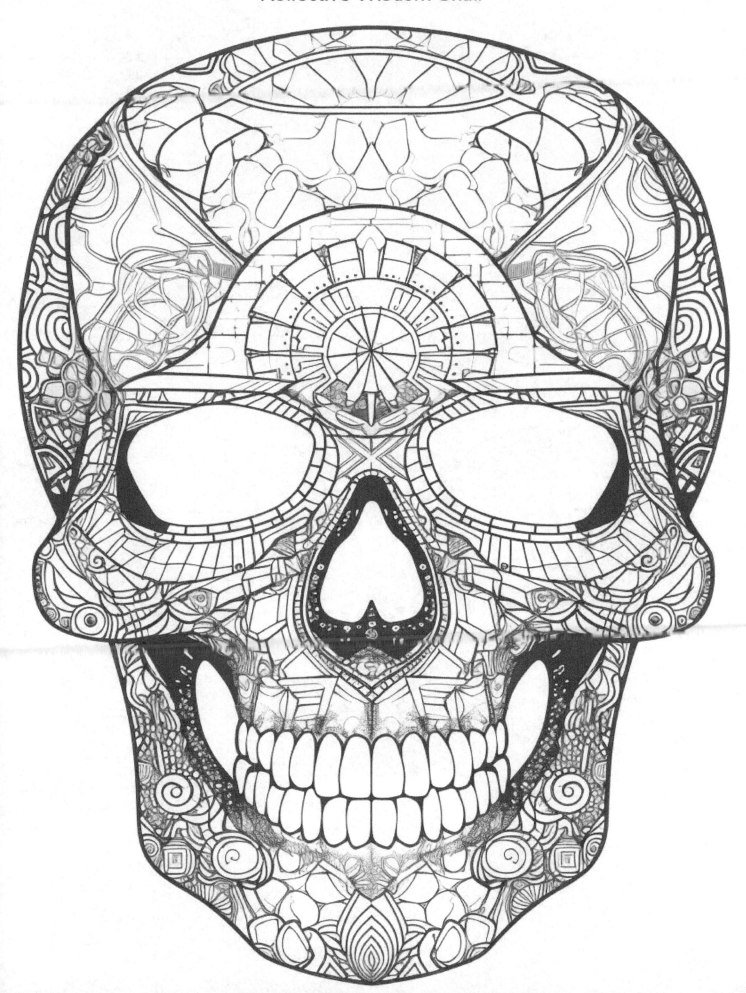

Be a beacon of hope in times of darkness

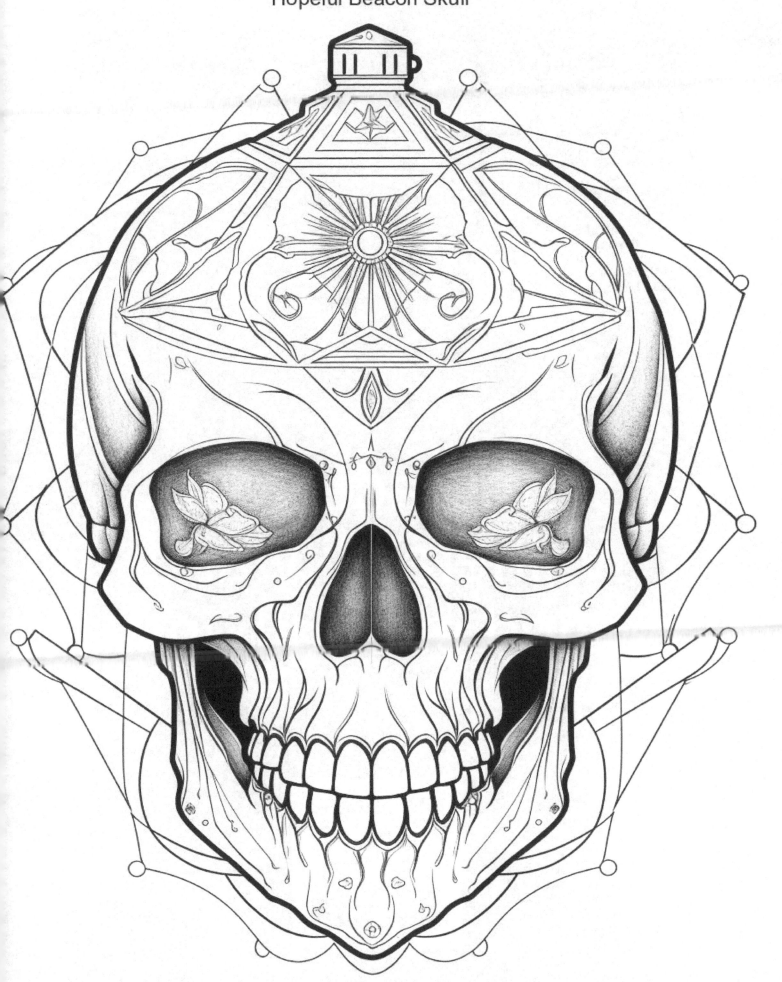

Hopeful Beacon Skull

Embrace your vulnerability and find strength in it

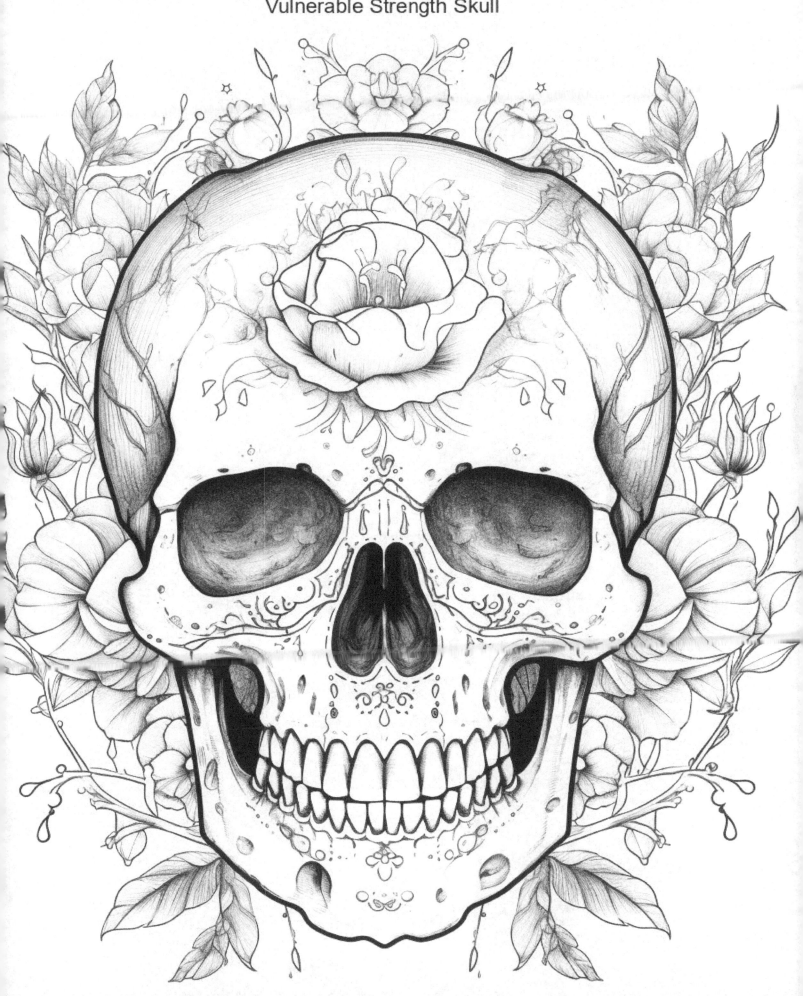

Nurture your mind, body, and spirit with care

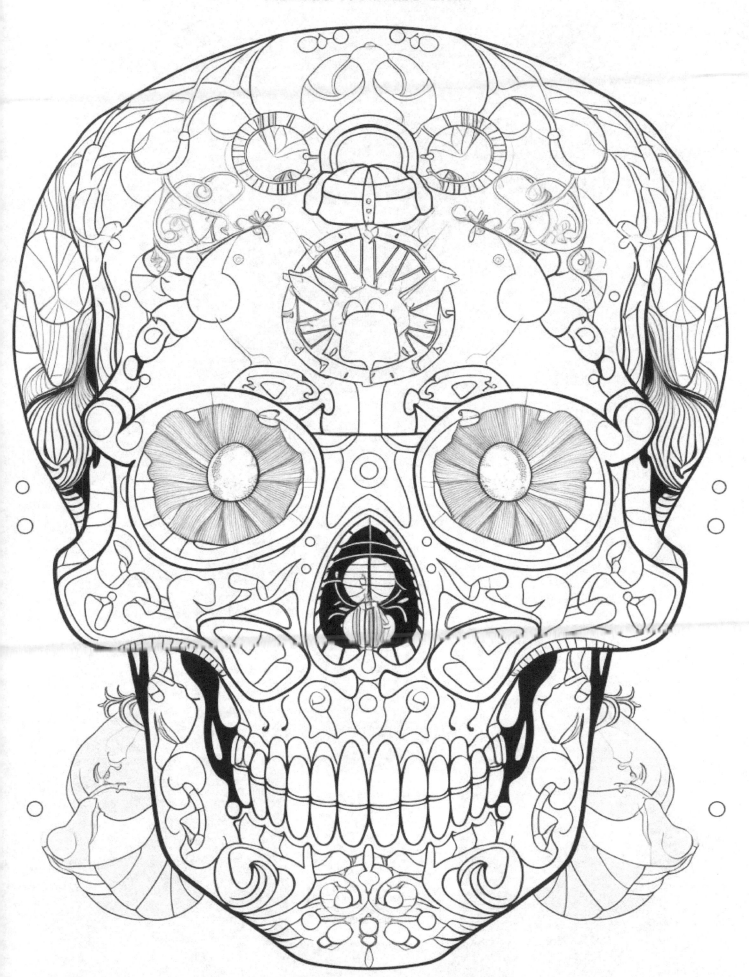

Celebrate the triumphs and learn from the challenges

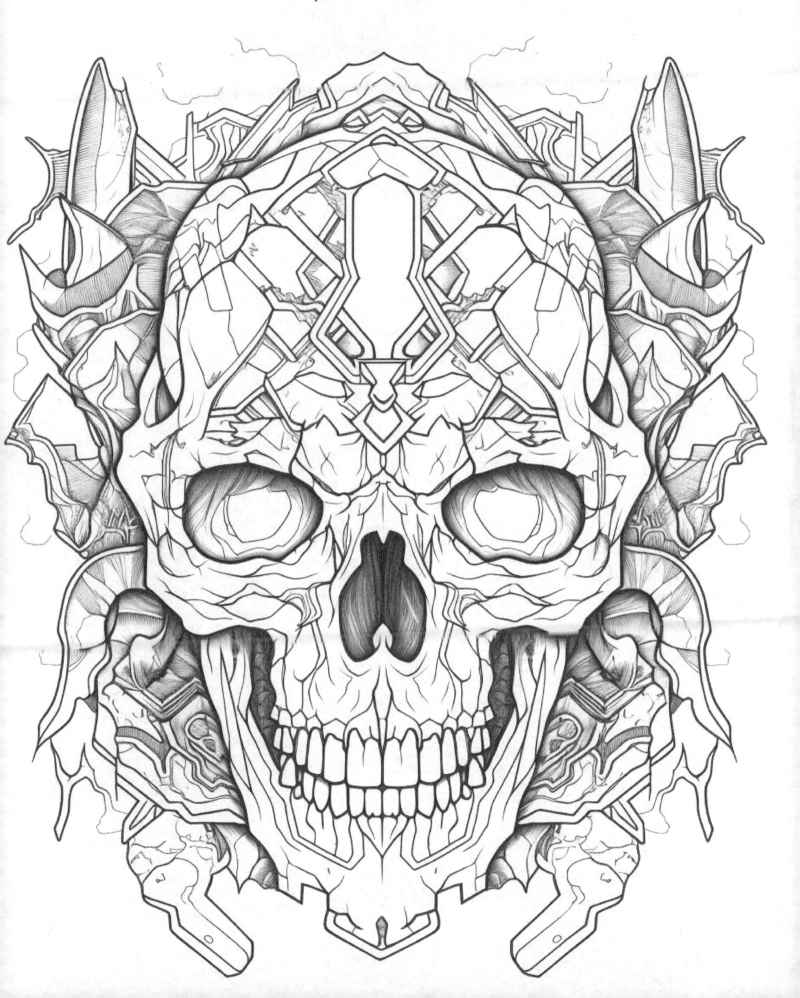

Embrace the magic of the present moment

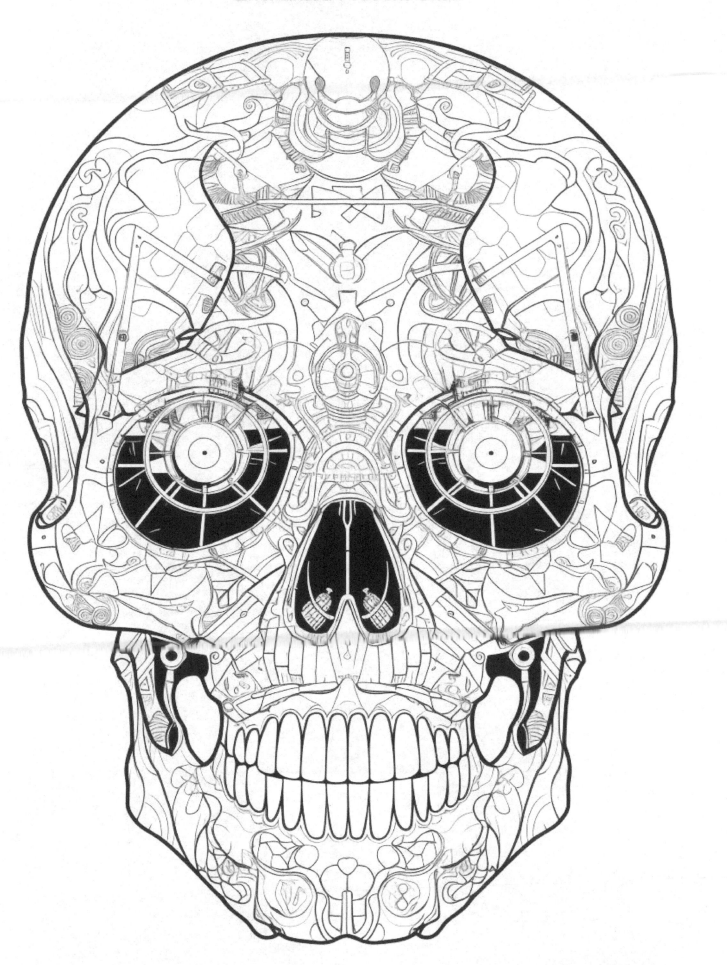

Find solace in the beauty of solitude

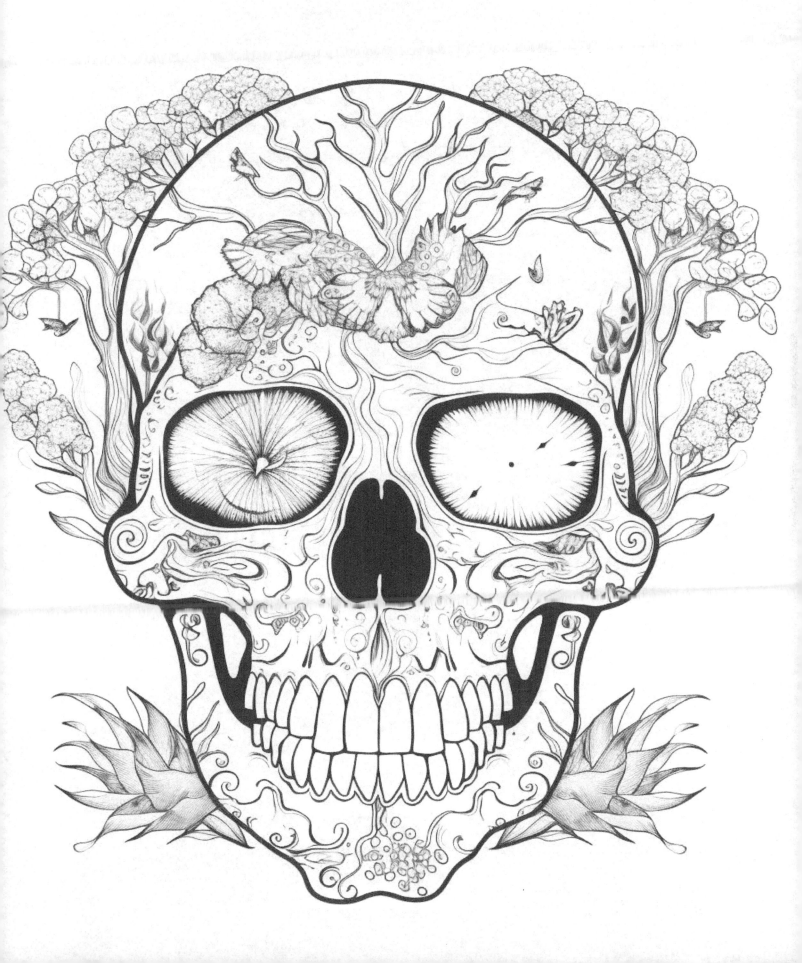

Choose happiness and let it fill your soul

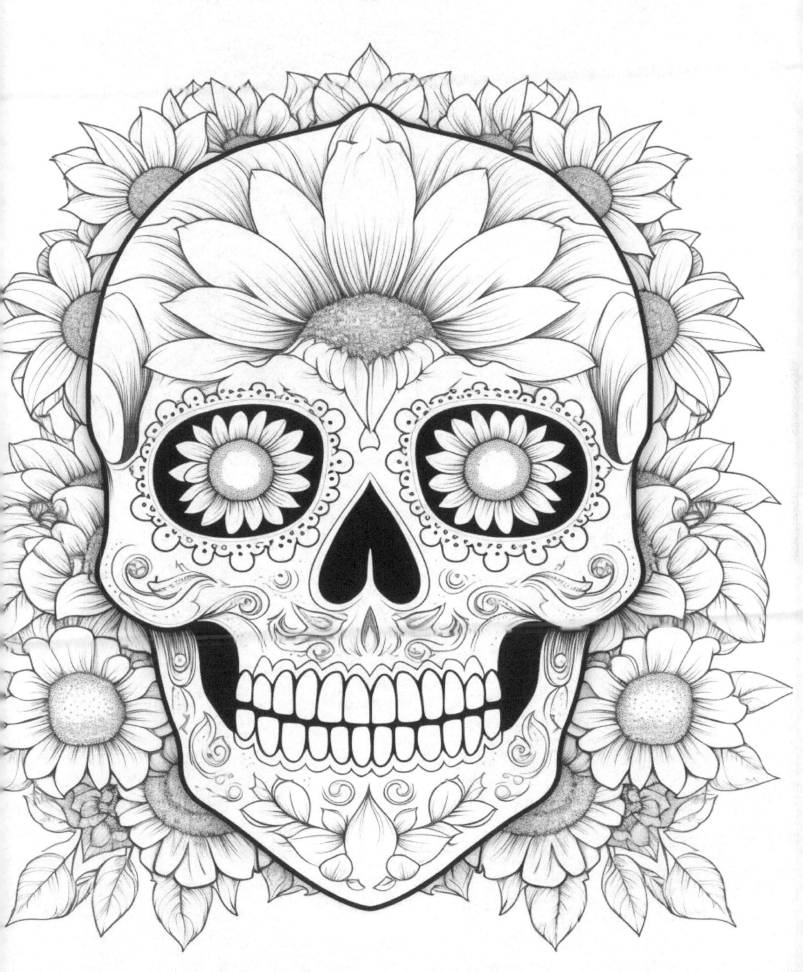

Embrace the journey of self-discovery

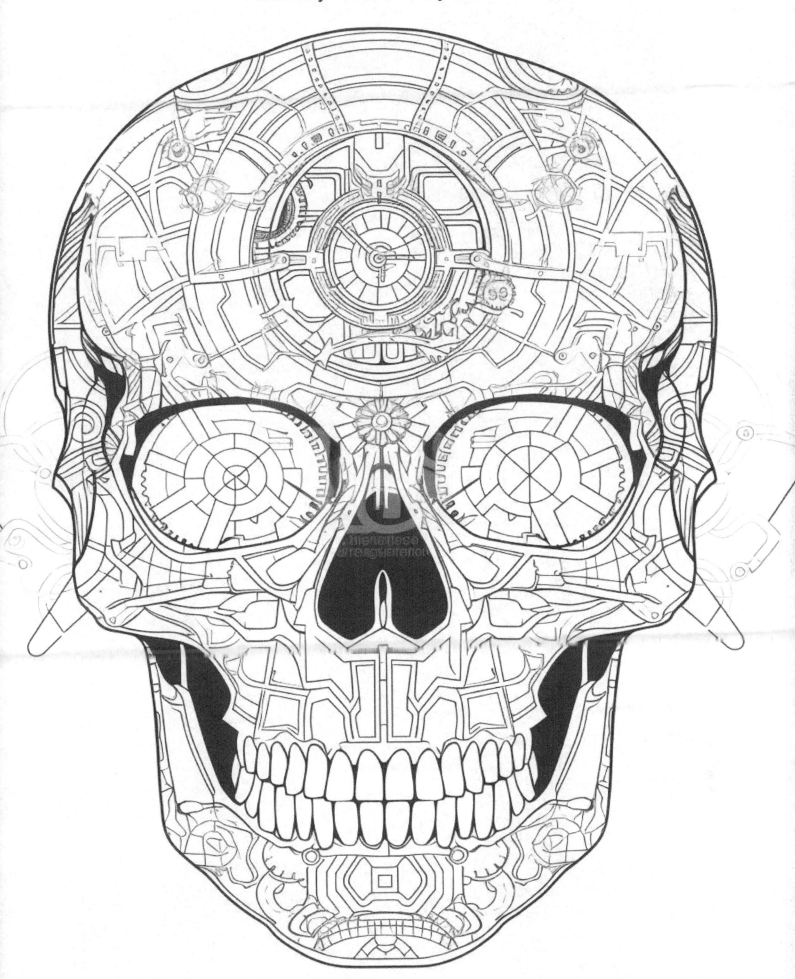

Believe in your ability to create a better world

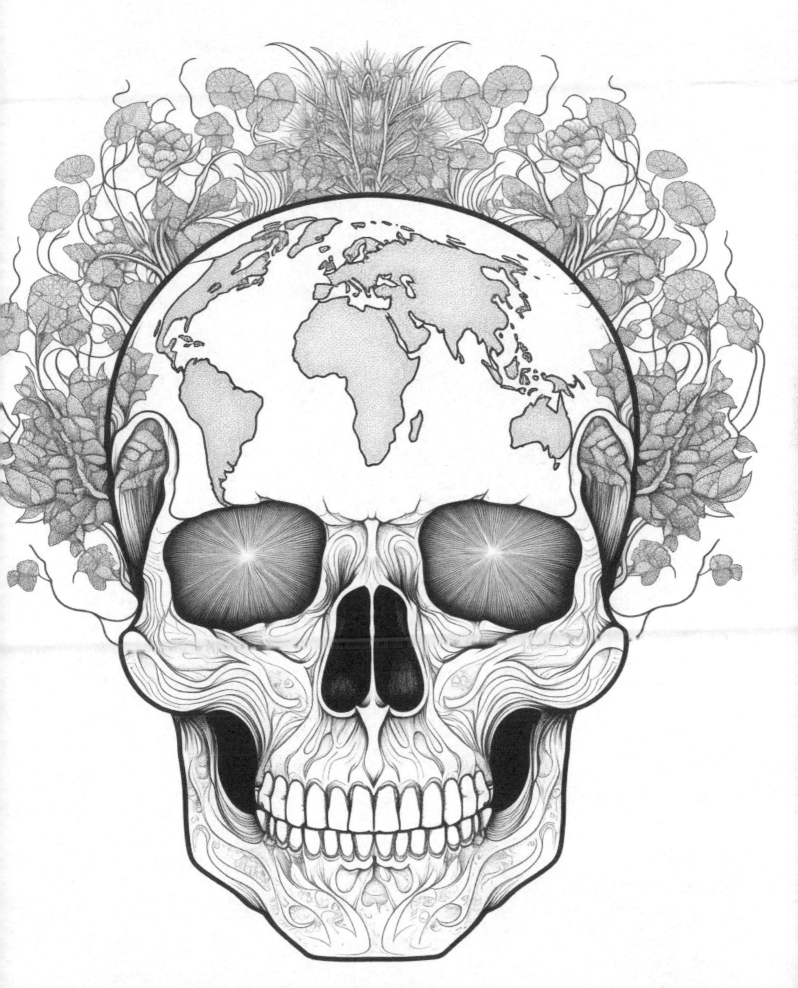

Reconnect with the wisdom of your ancestors

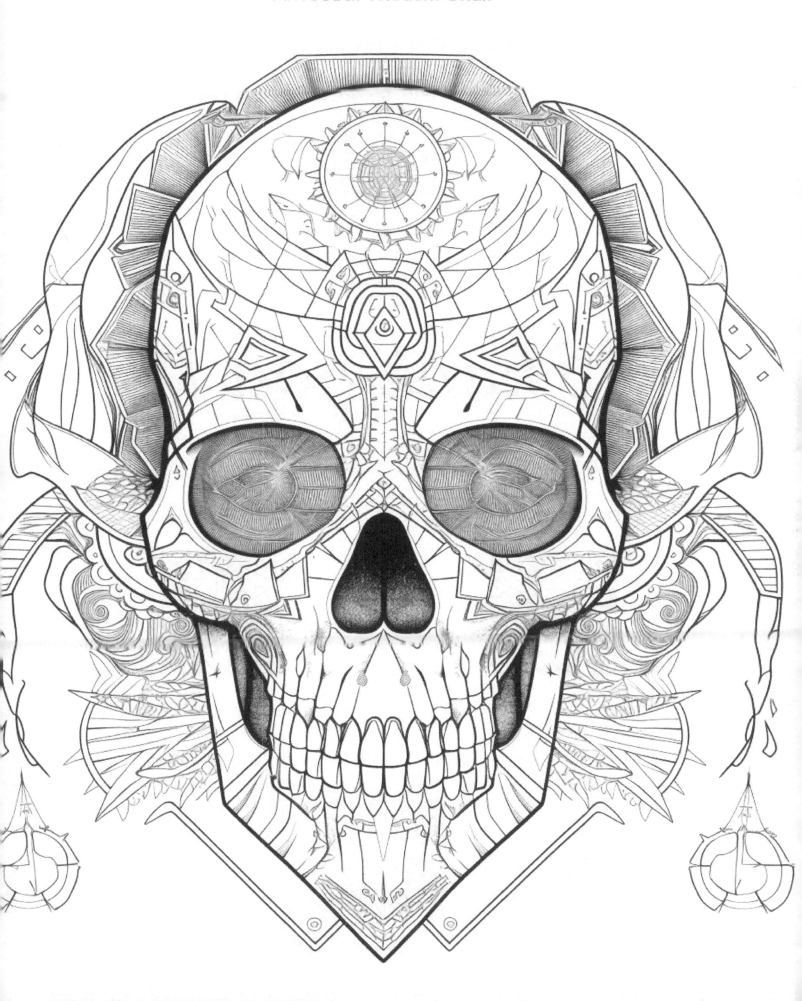

Including additional designs on line

www.g5cloud.com/lexmaxbelle-books/empowering-skulls/additional-designs-en.pdf

Thank you !

More books on

www.g5cloud.com/lexmaxbelle

Follow us

www.amazon.com/author/lexmaxbelle

Contact us

lexmaxbelle@g5cloud.com

Made in the USA
Las Vegas, NV
29 May 2023

72692464R00059